W9-BVD-708

IMAGES
*of America*

# FELL'S POINT

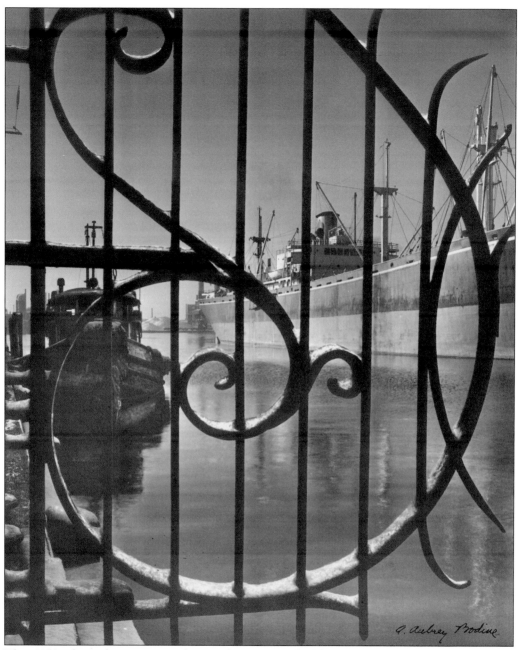

This 1950s photo shows a tug tied up at the City Pier building with a ship anchored nearby at Broadway Pier. (Photo by A. Aubrey Bodine, © Jennifer Bodine.)

*On the Cover:*
Every October, millions of people crowd the streets for the annual Fell's Point Fun Festival. This scene from the 1970s shows Thames Street from the water during one of the earlier festivals. (Photo by Lawrence M. Irvine.)

IMAGES
*of America*

# FELL'S POINT

Jacqueline Greff

ARCADIA
PUBLISHING

Published by Arcadia Publishing
Charleston, South Carolina

Printed in the United States of America

Library of Congress Catalog Card Number: 2005924320

For all general information contact Arcadia Publishing at:
Telephone 843-853-2070
Fax 843-853-0044
E-mail sales@arcadiapublishing.com
For customer service and orders:
Toll-Free 1-888-313-2665

Visit us on the Internet at www.arcadiapublishing.com

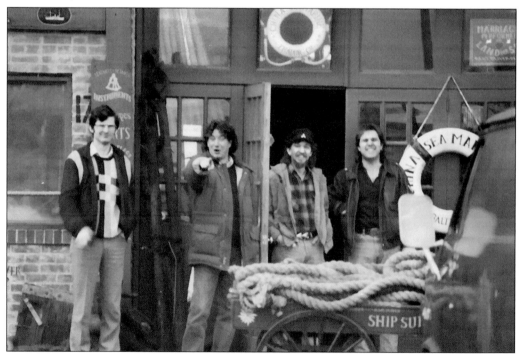

Although the seamen are no longer visible on the streets of Fell's Point, for many years the seafaring tradition was kept alive by Steve Bunker and Sharon Bondroff at their shop, The China Sea Marine Trading Co. An irresistible attraction, the shop sold marine-salvage and antiques, and educated locals and tourists alike from 1980 through 1999, when the couple left for Maine. Pictured here, from left to right, are Mike Fahey, John Martin, Steve Bunker, and Bill Oliver. (Photo by John Horn.)

# CONTENTS

# ACKNOWLEDGMENTS

Many, many people graciously opened their albums to me and spent hours providing information. The Preservation Society, whose full name is Society for the Preservation of Fell's Point & Federal Hill, opened their files to me. Without the help of Ellen von Karajan, Denise Whitman, Barbara Cromwell, and the hundreds of people who contributed photos to that important organization, this book would not have been possible. Additional local contributors included Nancy Caudill, Jim Widman, and Marty Bement with the Admiral Fell Inn; Billy Colucci; Joe Frank with Another Period in Time; Robert Eney; Ruth Gaphardt with the Art Gallery of Fell's Point; Anne Gummerson; Alicia Horn with Birds of a Feather; Cammie Kane with the Water Taxi; Mark Anthony Kozlowski; Charles and Darcy Norton with Sheep's Clothing; Brian Schwartz; Pauline and Stelios Spiliadis with the Black Olive; P. J. Trautwein; and Mark Walker with John's Hopkins Medicine. People I had never met sent me materials in response to e-mail requests—Dr. Jack Bobbitt provided photos of his painstaking model of the frigate *Virginia*, and Danish-American marine artist Torsten Kruse mailed me slides of his beautiful paintings of Fell's Point ships all the way from his gallery on an island in Denmark. Amy Hagovsky, from Barbara Mikulski's office, helped me identify last-minute photo options. Lawrence Irvine, an old friend of Vince Peranio, agreed to let me use his photos. And, of course, my faithful, long-suffering husband, Kraig B. Greff, supported, helped, and encouraged me through it all. I have meticulously tried to acknowledge photo contributors in the following pages. If a source is not named, it is because it is one of mine or is old, out of copyright, and available from numerous sources.

With shipping came sailors, and with sailors came bars. Fell's Point has one of the highest concentrations of bars and restaurants of any place in the country. Above, John and Alicia Horn pose in their bar, Birds of a Feather, in 1987. John, an avid photographer, died July 17, 2004, without publishing the book on Fell's Point he dreamed of writing. Alicia donated many of his photos to this book, making John almost a co-author. (Photo courtesy of Alicia Horn.)

# INTRODUCTION

Fell's Point was never an easy place to live—people with competing interests crowded together, fighting for survival. In the early days, founder William Fell and fellow shipbuilders and sea captains struggled against the sea, competing ports, and even Baltimore City, which eventually absorbed Fell's Point against its will in 1797. The few wealthy merchants who initially lived here fled during the yellow fever epidemics. In spite of these difficulties, Fell's Point's shipyards developed the famed Baltimore Clippers, built some of the navy's first ships, and financed the "privateers" that helped win the War of 1812. Many of the buildings lining its streets were built in the 18th and early 19th centuries by shipbuilders, sea captains, mariners, tradesmen, shopkeepers, and laborers in the shipping industry. With the advent of metal steamships after the Civil War, Baltimore moved its port facilities downstream, and the community began a long, slow decline. Fell's Point's bars, brothels, boardinghouses, and missions continued to cater to seamen, and it became the point of entry for waves of immigrants who found work in the canneries and other industries that thrived on its harbor location. Only the "uptown" area above Fleet Street was socially acceptable. When the Great Fire of 1904 swept through Baltimore, Pointers congregated in St. Stan's Church, praying for deliverance. The neighborhood was spared by several heroic fireboats and a shift in the wind. By the mid-1900s, what is now the historic district had become known as "the foot of Broadway" and was considered a slum. The city planned to clean it up by using federal money to route the East-West Expressway along the harbor and through its center. In its fight to "stop the road," Fell's Point became Maryland's first National Registered Historic District. As it recovered, a generation of bar owners, developers, entrepreneur shopkeepers, artists, and young couples looking to renovate cheap property battled for control of this tiny speck of turf. In more recent years, as Baltimore's Inner Harbor began to thrive, developers began tearing down historic homes and industrial buildings to build office and living spaces, setting the stage for another round of turf battles that is in full swing today.

I grew up in Iowa and had lived in nearly a dozen states before being transferred to Maryland. Kraig and I have always enjoyed living in cities. We chose Fell's Point partly because it reminded us of the tiny homes we had seen near the harbor in Annapolis. The area was fairly rundown at the time, with many empty lots accumulating trash. The house we bought on a 12-by-60-foot lot was one of the homes purchased by the city to build the freeway. It had been nicely renovated, but we soon learned that the new paint around the windows and doors hid rotting wood, which in turn hid a colony of active termites. We loved being able to leave our cars parked all weekend, walk out our door to dozens of restaurants and bars, and take a water taxi downtown any time we wanted. Attending occasional homeowners' association meetings and listening to ongoing complaints about the bars and parking was not as much fun. As a hobby, I began taking pictures of the buildings going up all around us in the no-longer-empty lots. Gradually, Fell's Point became home.

It wasn't until I accepted an early retirement package and began working full-time with my husband, however, that I really began to understand the community and to become aware of the resources slipping away with time. One of my first projects was a documentary, *Fell's Point Out of Time*, a poignant, provocative, sometimes funny, always revealing look at a community coping with change. Kraig and I interviewed 25 people who were knowledgeable about the area. The first was terminally ill "curmudgeon" Ed Kane, founder of the Water Taxi, who died the day after

our second interview. His brother-in-law was controversial photographer turned character actor Richard Kirstel, who moved to Spain before the documentary was finished. Kraig and I flew to Maine during a snowstorm to tape Steve Bunker and Sharon Bondroff, longtime residents, shopkeepers, and community leaders driven out by gentrification.

When I learned about the opportunity to write this book, I at first thought it would be simple, since I had already identified many photographs during production of my documentary and had accumulated extensive factual interviews. I discovered, however, that movies and print are very different media. Although both are a tribute to a very unique community, they tell different stories in different ways. My hope is that this book helps to capture the spirit and the amazing diversity of Fell's Point and to carry these memories forward so they are not lost with time.

The photo above was taken in 1994 when the *Nighthawk* was still anchored on Thames Street next to Recreation Pier. The *Nighthawk* was an 1880 U.S. Merchant Marine passenger vessel that had toured the Caribbean Islands, Mexico, and South America before coming to Baltimore in 1986. In 2002, Lew Diuguid, editor of the Fell's Point Citizens on Patrol newsletter, reported that the "official tall ship of Fell's Point" was sold and had gone off for Wilmington, North Carolina, without so much as a cannon round. (Photo by Anne Gummerson.)

# One

# THE RISE TO FAME
# AND FORTUNE

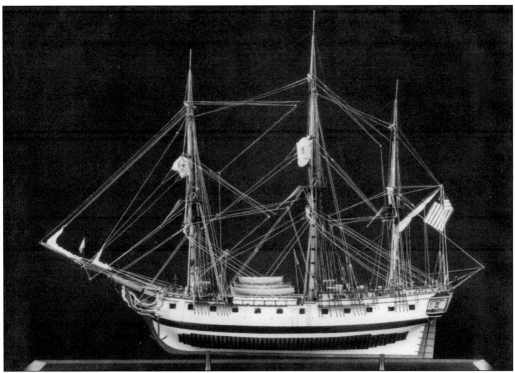

Fell's Point was founded in 1726 by William Fell, a shipbuilder from England. Baltimore's original deepwater port for over a century, Fell's Point shipbuilders developed the famed Baltimore Clippers, built two of the first ships in the U.S. Navy—the USS *Constellation* and the USS *Enterprise*—and financed the "privateers" that helped win the War of 1812. The Continental frigate *Virginia*, pictured above, one of 13 authorized by the Continental Congress in 1775, was laid down in 1776 at Fell's Point by George Wells. She was launched that August with Capt. James Nicholson in command. Joshua Barney was Nicholson's executive officer. (Model by John M. Bobbitt, M.D.)

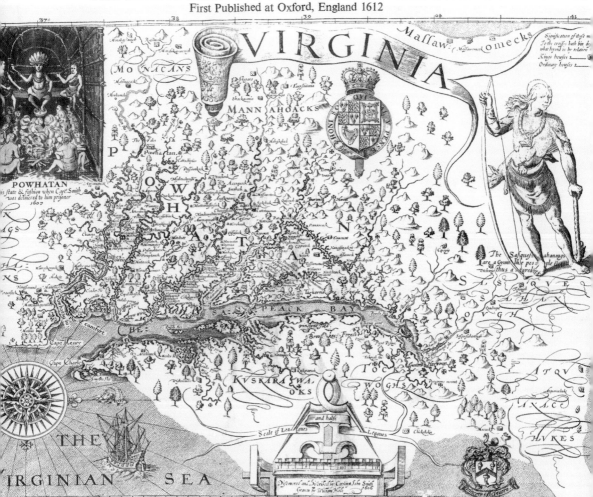

The first white man to visit Fell's Point was Capt. John Smith. Born in 1580 in Willoughby, England, Smith became an adventurer after his father died when he was 16. He had already fought in a number of countries before sailing to Jamestown, Virginia, in December 1606. In 1607, Smith was the only survivor of a group ambushed by Algonkian Indian deer hunters. Stories say he was spared because Pocahontas pleaded for his life with her chieftain father, Powhatan. In 1608, Smith sailed from Jamestown up the Chesapeake Bay, looking for the "Northwest Passage" to the Orient. His exploration included a voyage up the Patapsco River, where Baltimore is now located. Smith published this map in 1612 after his return to England. Although he never returned to "Virginia," he did revisit the New World to explore and map the Maine and Massachusetts Bay areas, naming the area New England.

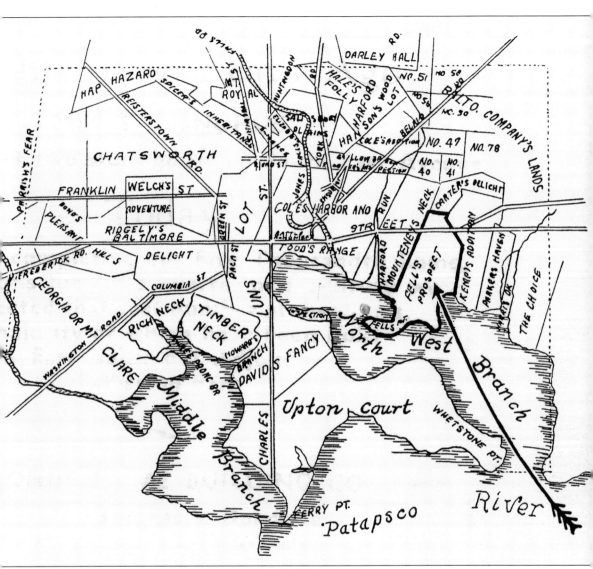

In 1661, David Jones settled on the banks of a stream now known as the Jones Falls, becoming the first settler in what was later named Jones Town by Edward Fell. In 1632, Caecilius Calvert, the second Lord Baltimore, became the first governor of Maryland under a charter from Charles I of England. In 1668, John Howard patented a tract that included a large part of South Baltimore. Thomas Cole took 550 acres of this in 1698, naming it Cole's Harbor. In 1730, William Fell, a shipbuilder from England, purchased 100 acres of Copus Harbor, naming it Fell's Prospect. The early map of Fell's Prospect above demonstrates its direct access to the Patapsco River that flows into the Chesapeake Bay.

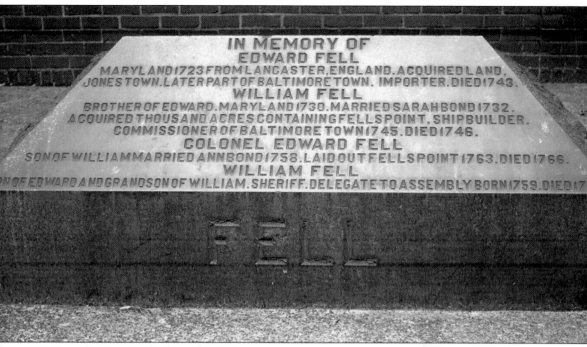

**IN MEMORY OF**
**EDWARD FELL**
MARYLAND 1723 FROM LANCASTER, ENGLAND. ACQUIRED LAND.
JONESTOWN. LATER PART OF BALTIMORE TOWN. IMPORTER. DIED 1743.
**WILLIAM FELL**
BROTHER OF EDWARD. MARYLAND 1730. MARRIED SARAH BOND 1732.
ACQUIRED THOUSAND ACRES CONTAINING FELLS POINT. SHIPBUILDER.
COMMISSIONER OF BALTIMORE TOWN 1745. DIED 1746.
**COLONEL EDWARD FELL**
SON OF WILLIAM MARRIED ANN BOND 1758. LAID OUT FELLS POINT 1763. DIED 1766.
**WILLIAM FELL**
SON OF EDWARD AND GRANDSON OF WILLIAM. SHERIFF. DELEGATE TO ASSEMBLY BORN 1759. DIED 17

FELL

According to popular lore, the males of the early Fell family are buried under this tombstone in a tiny graveyard on Shakespeare Street. Those who know the most about the history of the area are not so sure. Some say there was an old graveyard on the site and at least some of the Fells were probably buried there. Others point out that there was a separate Quaker meetinghouse on Fayette Street that had its own graveyard. This lot, where the tombstone resides, once also held a house. When it was torn down, Mrs. Losiewski and the other neighbors were glad to see the end of the rats that infested it. The stone above was carved in 1927 in preparation for Fell's Point's 1930 bicentennial. Today, the site is clean and clear, a popular spot for several competing ghost tours to bring visitors.

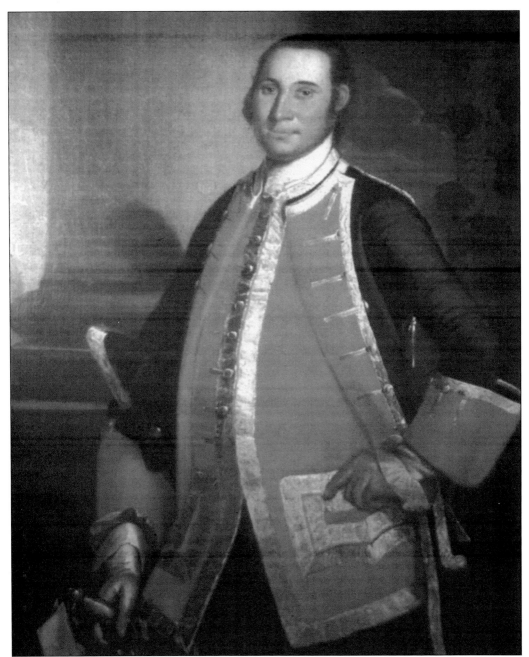

"Edward Fell, the youngest, the son of William Fell, the elder, and nephew of Edward Fell, the elder, inherited the greater part of his father's estate, including the dwelling. He married his cousin, Ann Bond, November 2nd, 1758, the daughter of John and Alice Anna Bond. . . . Of this marriage, there was one child, William Fell. . . . He laid out Fell's Point in 1763, and was a colonel in the Provincial Forces. He died in 1766, not over 33 years of age. . . . His portrait and that of his wife, painted by Hesselious, are now hanging in the drawing room of Rockland, Baltimore County." This is from an article by direct descendant William Fell Johnson, quoted in the *Fell's Point Bicentennial Jubilee* souvenir book in 1930.

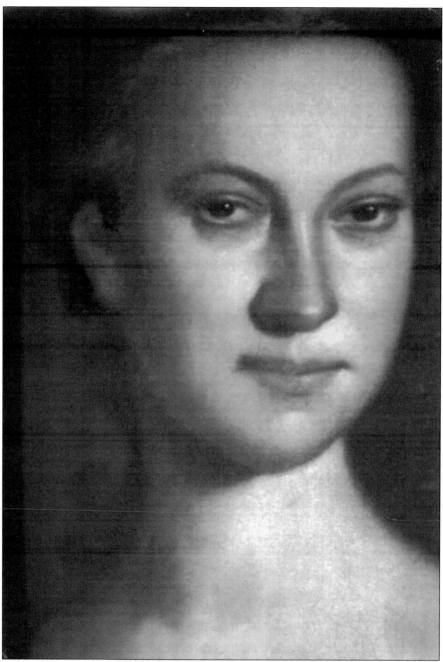

Ann Bond was Fell's Point's first female entrepreneur. According to architectural historian Robert Eney: "In 1763, Edward and his wife Ann laid out a town to be called Fell's Point. Once they started selling off the land in lots, Edward dropped dead. And so Ann Bond Fell went out and she sold Fell's Point. Now, Baltimore Town further up the harbor was still selling off lots, and people there started saying bad things about Fell's Point and about Ann being crooked and not giving good titles and had bad water and all this stuff. But her father John Bond advertised in the *Gazette and Daily Advertiser* that everything that Ann Bond said about Fell's Point was true and that he was staking his reputation on it."

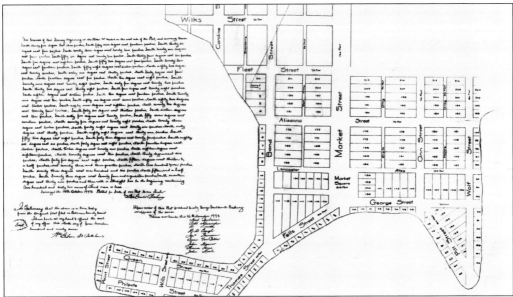

To be Sold Either Together or devided as may best Suit the Purchaser Five hundred acres of Land called Fells Forrest lying in Baltemore County about Twelve miles from Baltemore Town on the main road that leads to Fredirick, also as well as on ground rent a fee simple to lots of ground in a plan for a Town lately laid Out on a point Called Fells Point near Baltemore Town on Patapsco River, good Titles will be Given to Land and Lots for Terms Enquire of the Subscriber living on the said Point — 1763 May 23: 1763

This 1763 land advertisement by John Bond includes Fell's Point. "John Bond, merchant, was one of the first citizens of that part of town, a Justice of the Peace and a rich man. A street in Baltimore bears his name, a nearby street that of his wife, Aliceanna, another of his daughter, Ann," notes John H. Scaiff in his 1936 *Historic American Buildings Survey* write-up about 1621 Thomas Street.

In this Fell's Point plat dated 1773, a number of street names are different than today: George and Fell Streets are now Thames. Wilks Street is now Eastern Avenue. Market Street is Broadway. Apple Alley is Bethel. Strawberry Alley is Dallas. Petticoat Alley is Spring. Argyle Alley is Regester. Happy Alley is Durham. Star Alley is Chapel. Pitt is Fell Street. Queen Street is Block. Alisanna is now spelled Aliceanna.

15

An article in the *Fell's Point Bicentennial Jubilee* souvenir book in 1930 quotes direct descendent William Fell Johnson as saying: "William Fell, the younger, son of Edward Fell, the younger, was born August 29th, 1759, and was 'put to the study of law' in compliance with his father's wishes contained in the will. He was made Sheriff in 1780 and later became a member of the Assembly. The Maryland Chronicle records his death on Friday, October 6th, 1786, only 27 years of age and burial in the family vault on Shakespeare Street. When visiting Paris, his miniature was painted and is now at Rockland, Baltimore County."

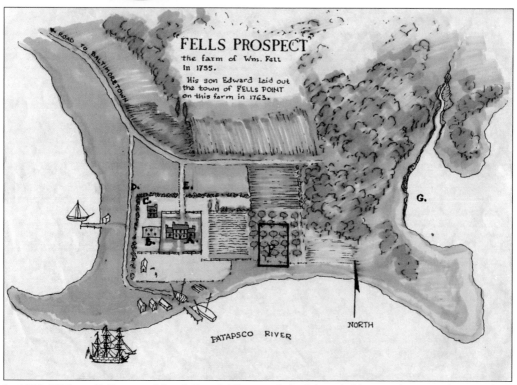

In 1732, William Fell married Sarah Bond. The couple had five children and operated a sprawling farm. William also owned and operated shipyards in Fell's Point and a number of mills on the Jones Falls. This oversimplified map was prepared by Robert Eney for students at St. Stanislaus School.

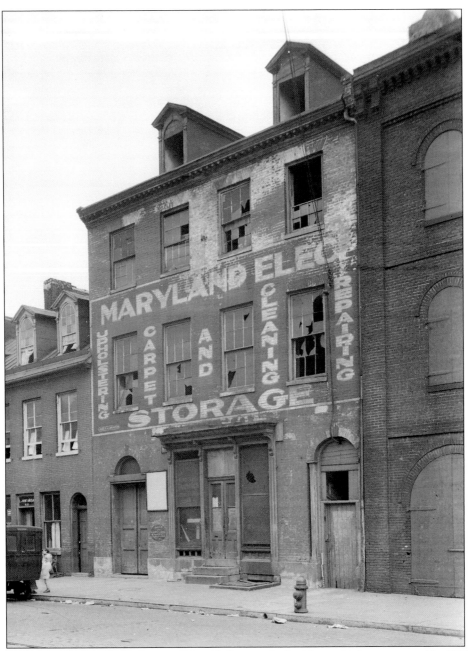

"Through the efforts of State Senator John H. Bouse, the building which was erected by William Fell as his home in 1730 has been located at 1621 Thames Street," said the 1930 *Fell's Point Bicentennial Jubilee* souvenir book. Investigator John H. Scaiff, in his 1936 investigation for the *Historic American Buildings Survey*, disagreed. "Local legends associate the building with the home of the Fell family. . . . It is so obviously built as a house in a row and Thames street of ancient date it is thought this legend incorrect. It is thought to have been built between the years 1763 and 1798." The building was torn down in 1937 to make room for the Brown's Wharf complex of shops and offices. (Photo by E. H. Pickering, 1936, Library of Congress, Prints & Photographs Division, HABS, MD, 4-BALT, 21-1.)

No, said Robert Eney. The original Fell house was located at 1609 Shakespeare Street, near the Fell family graveyard, and had a long driveway onto Lancaster Street. William Fell was a Quaker, and his original home was a Quaker design. Above is the house in the 1970s before it was restored. As the family grew and prospered, the "mansion" complex expanded. In 1794, the buildings were sold as a group. "We have the newspaper ad [opposite page]," said Robert Eney. (Photo courtesy of the Preservation Society.)

Across the street at 1600 Shakespeare is the "Cottage," believed to have been the kitchen building to the Fell family farm. On the first floor is a huge fireplace, eight feet wide and tall enough for a man to stand in the opening. The second floor was one room for slaves or servants, with a wooden divider down the middle. (Library of Congress, Prints & Photographs Division, HABS, MD-346.)

This is the 1790 advertisement mentioned by Robert Eney selling off the group of buildings described as "Fell's Mansion-House."

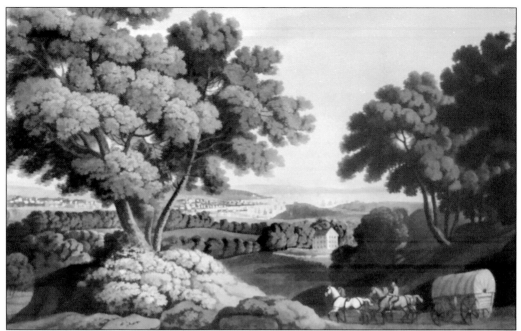

Baltimore Town, Jones Town, and Fell's Point, which eventually merged to form Baltimore City, developed as separate villages. There were a number of grain merchants in Baltimore Town. Fell's Point had the shipyards, where the larger "off-shore vessels" docked and the grain was shipped. In this early painting, Fell's Point is visible in the distance from the hills on the west overlooking the village.

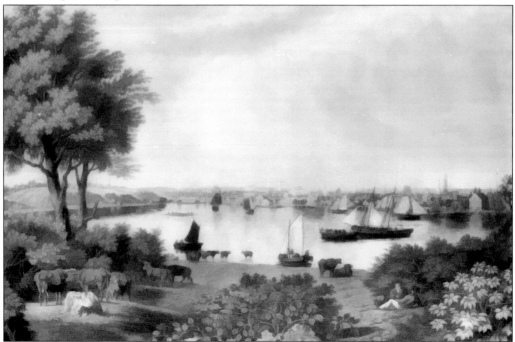

In the second print, titled *Baltimore from Whetstone Point, 1830*, the city of Baltimore lies spread out across the center of the horizon. A few Fell's Point buildings are visible on the right.

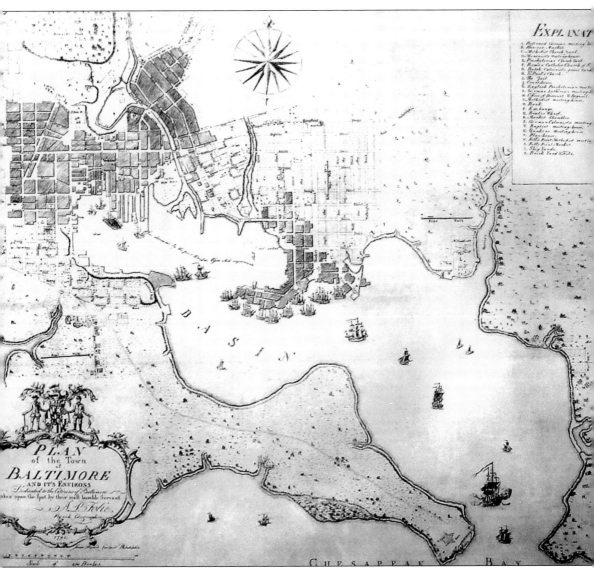

The earliest known detailed map of Baltimore was by A. P. Folie in 1792. At the time, the population was only 13,500. The settled area in the northwest is the original Baltimore Town, with Jones Town on its northeast side. Fell's Point is in the center above the word "Basin." Fort McHenry is the star on the lower right, to the left of the ship entering the Basin. By 1796, Fell's Point had 47 taverns and inns, along with red light districts and dance halls. In *Baltimore on the Chesapeake* (1941), Hamilton Owens comments, "Geographically, Fells Point in those days, showed a definite hook point and as the prostitutes took over, one wonders if it is responsible for the term hookers." From 1773 to 1782, a series of annexations added portions of Fell's Point to Baltimore Town. In 1793, Maryland considered a charter for Baltimore City, but Fell's Pointers protested so vehemently that it was dropped. Historian Geoffrey Footner lamented that finally "in 1797, the City of Baltimore came to exist and reduced Fell's Point to practically being a medieval vassal to the city."

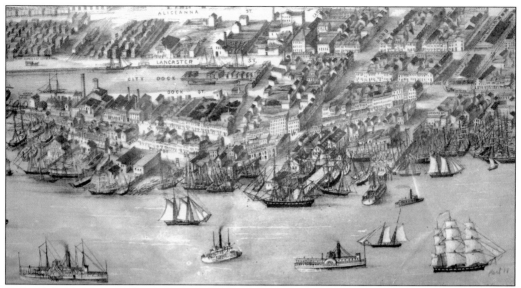

S. B. Nelson's *History of Baltimore, 1729–1898* notes: "Fell's Point was always a nest of sailors, and . . . the centre of the shipping industry of the port. Here lived captains, petty officers and thousands of native sailors. Tar and pitch were preeminent. Rope walks abounded, joiner worker shops, ship-smiths and forges were sandwiched between sailors' boarding houses and ship chandlers' stores." (Drawing from E. Sachse, & Co.'s bird's-eye view of the city of Baltimore, 1869.)

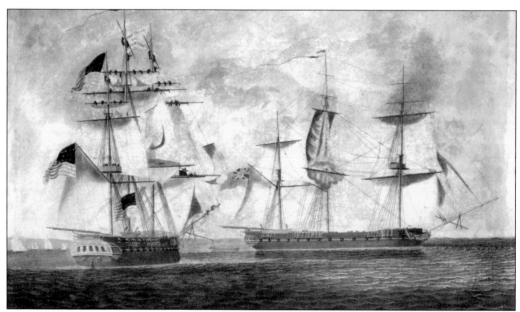

Even after the United States won its independence, British naval vessels continued to stop American vessels and impress American citizens by the thousands. In 1807, the *Chesapeake*, a U.S. frigate built by Fell's Point De Rochebrun shipyard, was attacked by the British HMS *Leopard* after it refused to turn over "deserters." The incident enraged Americans, setting the stage for the War of 1812. (1813 aquatint by Robert Dodd.)

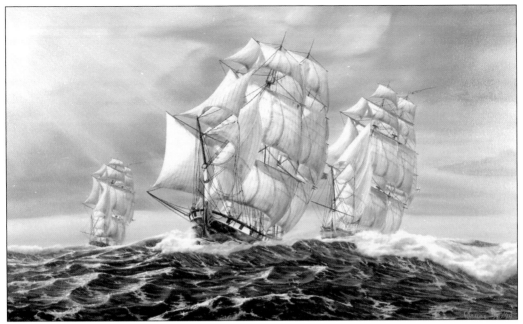

During the 15 years Danish-American marine artist Torsten Kruse lived in Maryland, he was inspired to paint this series of Fell's Point vessels. Kruse now has a gallery on a Danish island (www.KruseMarineArt.dk). The *Hannibal* was built in Fell's Point in 1811 by William Price shipyard. In *The Taking of Hannibal*, two British frigates chased her for one and a half days before capturing her. She was later commissioned as the HMS *Andromeda*.

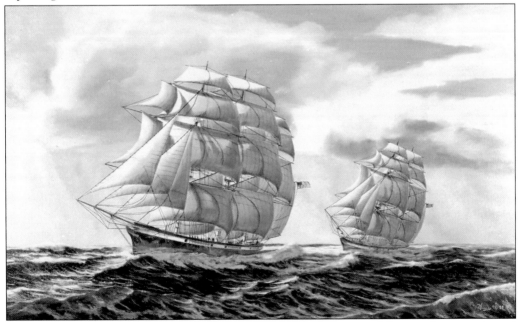

The *Ann McKim*, pictured in *Ann McKim & John Gilpin*, was one of America's most admired vessels. She was built in Fell's Point by Kennard & Williamson for wealthy merchant Isaac McKim with little regard to cost, and she was named after his wife. She launched in 1833 to an "immense . . . concourse of spectators" and "glided off in the most delightful manner."

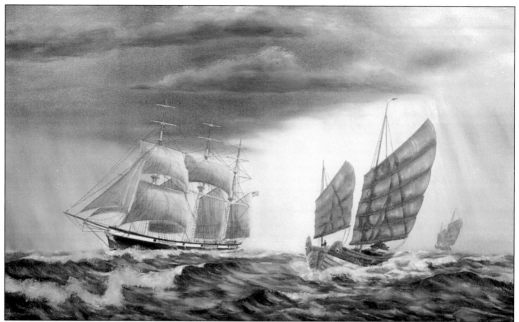

The *Ann McKim* was designed to cover long distances quickly and sailed in the China trade for many years. In *Ann McKim on the China Coast*, Kruse depicts the ship off the China coast passing a couple of Ningpo fishing junks.

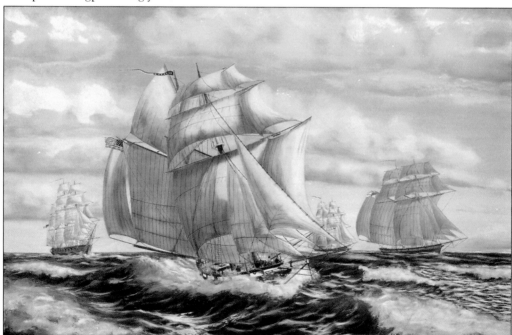

Fell's Point was famous for its "privateers," privately owned armed vessels given a "letter of marque" that commissioned them to seize enemy ships as a "prize." The *Comet of Baltimore* was a privateer built by Thomas Kemp in 1810. On her very first cruise, Capt. Thomas Boyle brought back prizes worth $400,000. In this painting, Kruse depicts the *Comet* under all "kites," slipping away from several British vessels.

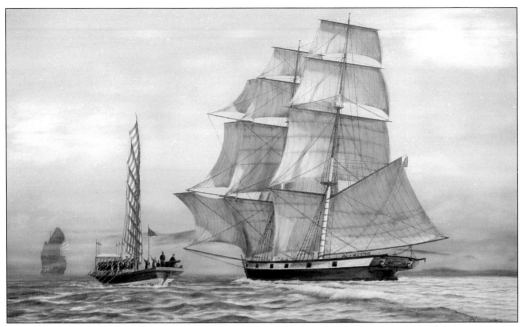

The *Chasseur*, built by Thomas Kemp, was one of the largest and most successful privateers in the War of 1812 under Capt. Thomas Boyle. After the war, many other Baltimore schooners ended up as slavers or outright pirate ships, but the *Chasseur* became a successful Chinese trader because of her speed and size. In *On Approach to Canton*, Kruse depicts the *Chasseur* passing a Chinese police gunboat.

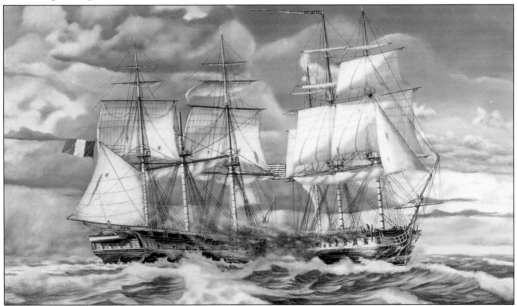

The 38-gun *Constellation*, named for the "new constellation of stars" on the flag, was the first frigate to be commissioned for the U.S. Navy. She was built at Stodder's shipyard and launched in 1797. In Kruse's painting *Constellation vs. L'Insurgente*, the French frigate had tried to get in front of the *Constellation* to rake her from the bow but misjudged the speed and found herself head on to a full broadside.

Official histories show that the *Constellation* was broken up at the navy yard in Portsmouth, Virginia, in 1853. Her namesake, the USS *Constellation*, built in 1854, now resides in Baltimore's Inner Harbor. In his 2002 investigative study, *USS Constellation: From Frigate to Sloop of War*, historian Geoffrey Footner covers the 204-year history of the USS *Constellation*, launched at Fell's Point in 1797 and redesigned and repaired several times, including her rebuilds of 1812, 1829, 1839, and 1853. He has convinced a number of authorities that the *Constellation* sitting in Baltimore harbor today is the 1797 frigate and the oldest surviving ship of the U.S. Navy.

# *Two*

# SAILORS, IMMIGRANTS, AND INDUSTRY

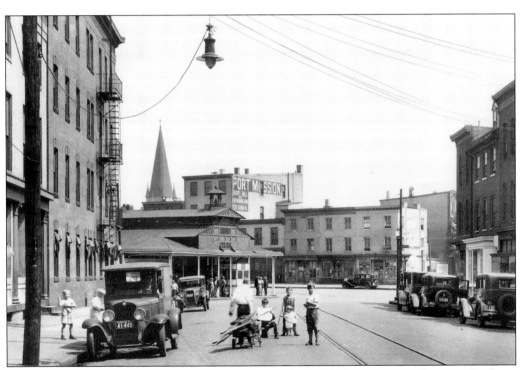

With the advent of metal steamships after the Civil War, Baltimore moved its port facilities downstream, and the community began a long, slow decline. Fell's Point's bars, brothels, boardinghouses, and missions continued to cater to seamen, and it became the point of entry for waves of immigrants who found work in the canneries and other industries that thrived on its harbor location. This 1930s photo shows the 1600 block of Thames Street looking east. In the center is the southernmost Broadway Market building, which no longer exists. (Photo by A. Aubrey Bodine, © Jennifer Bodine.)

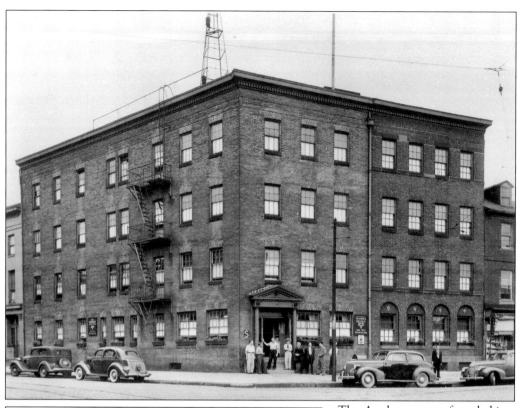

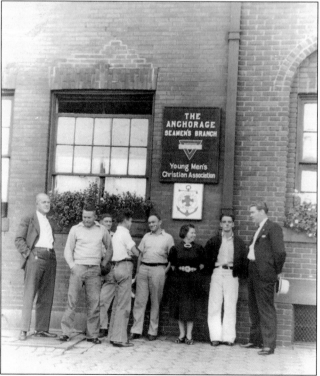

The Anchorage was founded in 1892 as an extension of the Port Mission to provide boarding for seamen. The first building was located where the Recreation Pier now stands. The building above was erected in 1900. The YMCA ran it from 1929 to 1955, when it closed, having served over 5 million seafarers. For the next 20 years, it housed a cider and vinegar factory. It has been the Admiral Fell Inn, a historic hotel, since 1985.

This photo shows executive secretary Frank Mitchell and various members outside the Anchorage Seamen's Branch, YMCA, on September 9, 1938. (Photo above by the Hughes Co.; photo to the left by G. H. Anderson; both courtesy of the Admiral Fell Inn.)

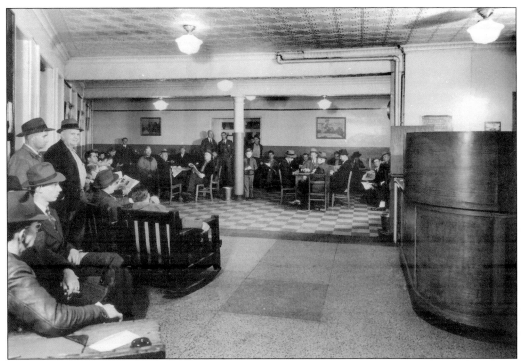

Above are the lobby and reading room of the Anchorage in 1942. According to Steve Bunker, Fell's Point was once known as "Shanghai town" and "an exceedingly rough place." One of America's last shanghai incidents occurred as recently as 1948. Seaman Jim Tomas went to sleep in his bed at the Anchorage one evening and woke up on a Chinese freighter bound for the African coast.

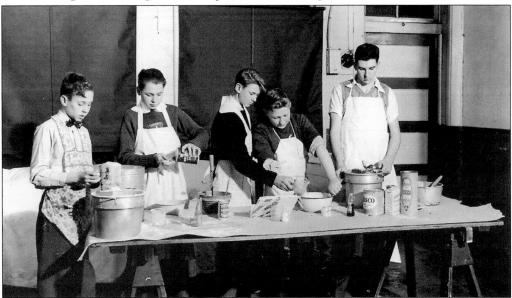

Above is a photo of the boys of Hamilton Junior High Y Club baking cookies for the seamen's Christmas packages. Three thousand or more packages were distributed each Christmas season. Over 200 groups and 1,000 individuals cooperated to bake, pack, and distribute the packages. (Photos by the Hughes Co., courtesy of the Admiral Fell Inn.)

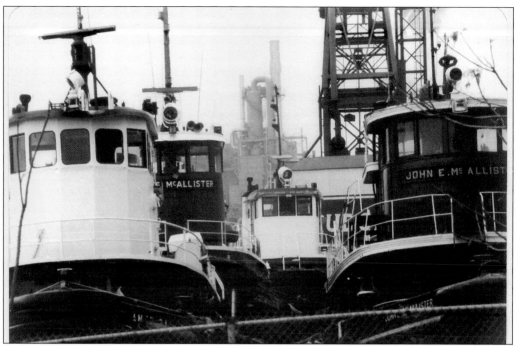

Tugboats have been a fixture in Fell's Point since Vane Brothers moved here from Inner Harbor in the 1950s. In this 1972 photo, a series of tugs are stacked with Domino Sugar as a backdrop.

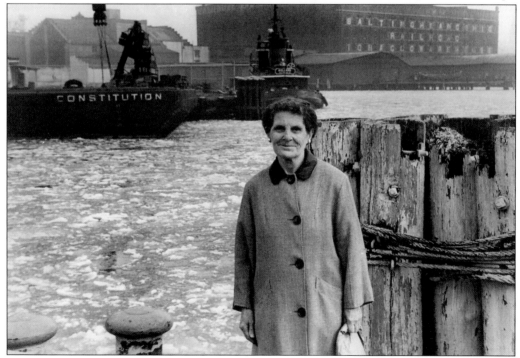

In this 1930s photo, an unknown woman poses on Broadway Pier. In the background, a ship and tug are tied up at Recreation Pier. Henderson's Wharf is visible at the right rear. (Both photos courtesy of the Preservation Society.)

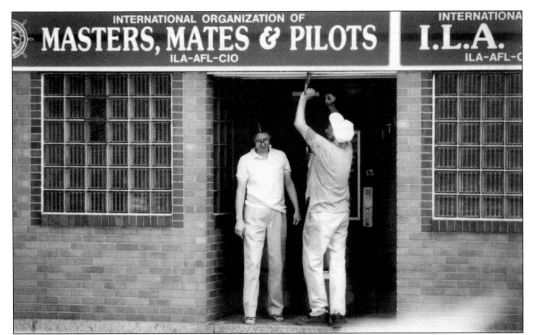

Low wages and poor working conditions gave rise to a number of seamen's unions. The International Longshoremen's Association (ILA) building above was located on Aliceanna Street. For a detailed account of strikes, boycotts, and union battles that occurred here in the 1920s and 1930s, see *The Baltimore Book: New Views of Local History*, chapter eight, by Linda Zeidman and Eric Hallengren. (Photo by John Horn.)

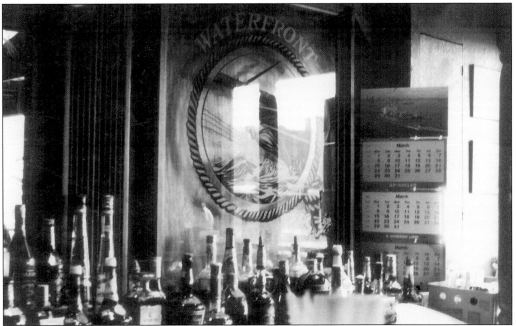

With the sailors also came bars that catered to them. This photo is from inside the Waterfront bar in 1972, across from the tugs on the upper left of the opposite page. The Waterfront was featured in many episodes of the *Homicide* TV show. (Photo courtesy of the Preservation Society.)

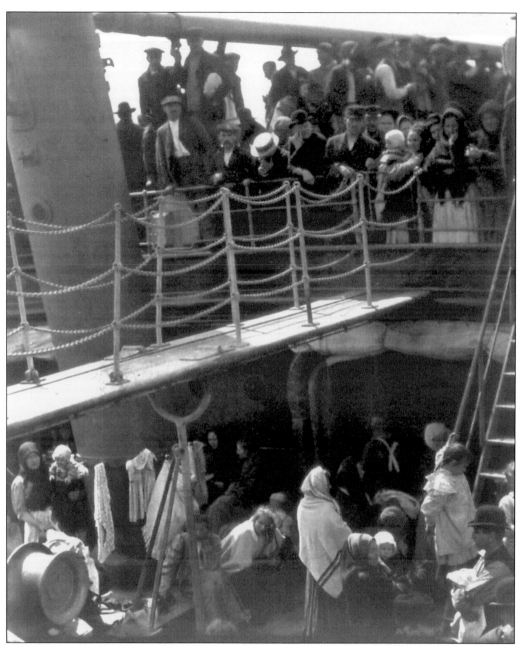

In the late 19th and early 20th centuries, Baltimore was one of the leading ports of entry for immigration into the United States, second only to Ellis Island. By 1913, Baltimore was averaging 40,000 immigrants per year, and immigration had become a big business. Conditions in the economy accommodations or steerage of the ships of this era were deplorable. Sanitation and ventilation were poor, and washrooms and lavatories inadequate. Each person had a berth for sleeping and storage of baggage that measured six feet by two feet, with two feet of space above. In the 1907 photo above, *The Steerage*, passengers crowd onto the deck for fresh air. (Photo by Alfred Stieglizt, Library of Congress, Prints & Photographs Division, LC-USZ62-62880.)

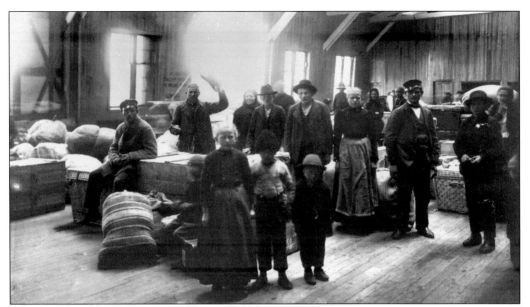

Between 1830 and 1850, thousands of Germans from Bremen landed at Henderson's Wharf. By 1868, a fourth of the 160,000 population of Baltimore was German. Poles began to settle here in the 1880s, and by the 1920s, they outnumbered all other ethnic groups. This photo shows a group of Polish immigrants arriving at the Baltimore & Ohio (B&O) Railroad terminal in Locust Point, c. 1895.

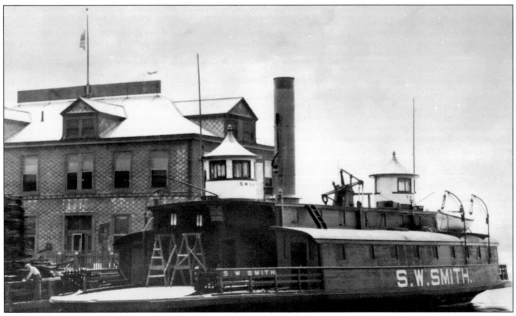

Early immigrants coming to Baltimore sailed directly into Fell's Point. However, after the Irish potato famine in the mid-1840s and the German political uprisings of 1848, the numbers became so great that the B&O Railroad constructed terminals across the river at Locust Point, next to Fort McHenry. Those who did not purchase train tickets west rode the ferry to Fell's Point. The renovated and repainted ferryboat S. W. Smith, photographed in 1920, operated the Locust Point to Broadway route on a 20-minute schedule from 6:00 a.m. to 10:00 p.m.

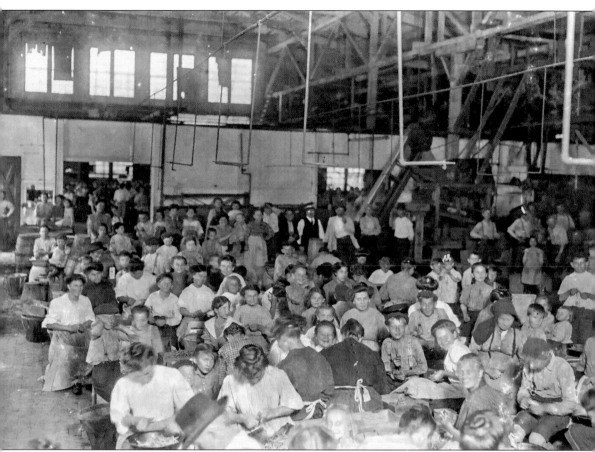

Beginning in the 1830s, canneries began to line the Baltimore waterfront. By the end of the century, canning had become an important source of employment for Fell's Point immigrants, and Baltimore had become the canning center of the United States. The photographer's notes read: "Group, showing a few of the workers in the J. S. Farrand Packing Co., stringing beans. Those too small to work are held on laps of workers or stowed away in boxes." Women brought their children because no babysitters were available, and the kids could make a little money, too. Women and children were preferred for cannery work over men because they would work for lower wages. The J. S. Farrand Packing Co. was located in Fell's Point at the foot of Wolfe Street. (Photo by Lewis Wickes Hine, 1909, Library of Congress, Prints & Photographs Division, LC-DIG-nclc-00030.)

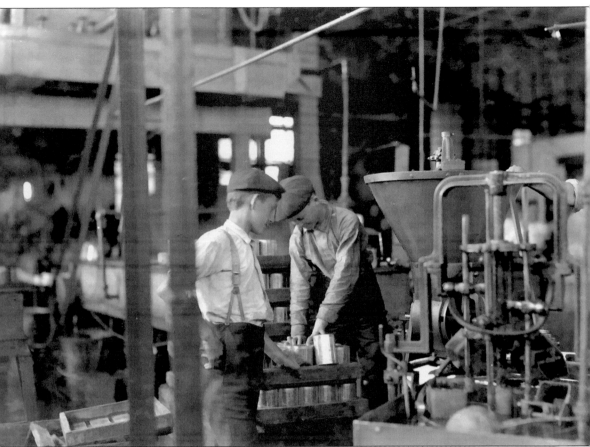

Lewis Hine is recognized as one of the pioneers of documentary photography. A New York City schoolteacher and photographer, he quit his teaching job in 1908 to become an investigative photographer for the National Child Labor Committee, which was conducting a campaign against the exploitation of American children. Hine often took great personal risks and used tricks to get into factories, claiming to be a fire inspector, photographing machinery and other views. In this 1909 photo at the J. S. Farrand Packing Co., small boys were hired to work around often-dangerous packing machines. Fell's Pointer Eleanor Lukowski once described getting her skirt caught in a similar machine. Feeling herself being pulled into it, she stripped off her skirt. "Hon, I didn't care if all them men were there!" (Photo by Lewis Wickes Hine, Library of Congress, Prints & Photographs Division, LC-DIG-nclc-00752.)

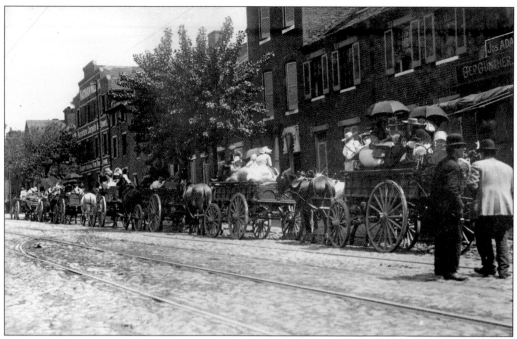

These 1910 photos show Baltimore immigrants lined up on Wolfe Street, near Canton Avenue (now Fleet Street), ready to start for the country to work on the berry farms. Many Polish immigrant families in Fell's Point migrated to the work, picking fruits and vegetables in the nearby countryside in the spring, working in the canneries in the summer, then migrating to the Gulf Coast to work in the shrimp and oyster packing plants, to return to Fell's Point again the next spring. (Photos by Lewis Wickes Hine, Library of Congress, Prints & Photographs Division, LC-DIG-nclc-00193 and LC-DIG-nclc-00190.)

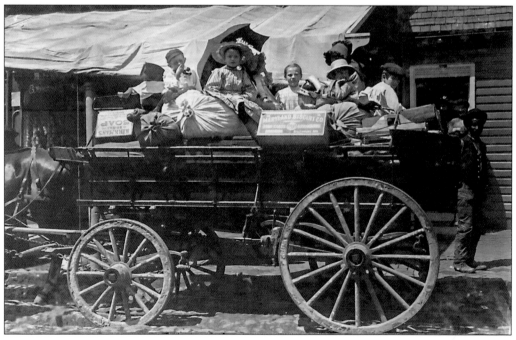

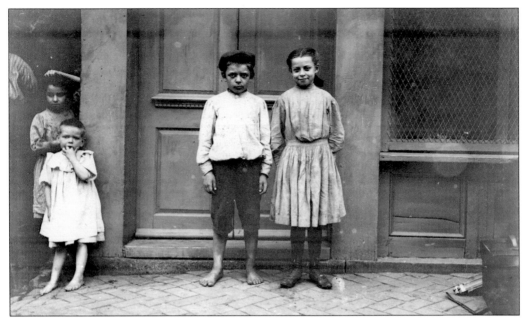

Marie Kawalski is 11 in this picture, and her brother Albert is 10. The previous winter, they worked with their mother shucking oysters for Varn & Beard Packing Co. on Young Island, South Carolina. Photographer Lewis Hine said, "Mrs. Kawalski did not have things represented to her correctly and she found that all the children that had fare paid were compelled to work for the company."

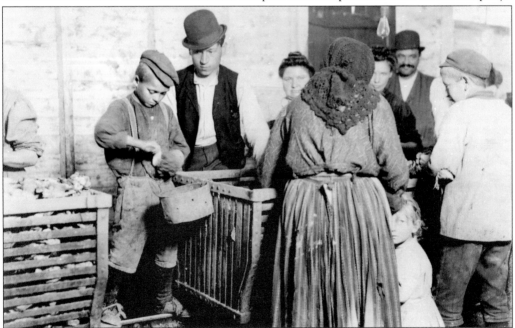

"Nine-year-old Johnnie" and his family were brought from Baltimore to Dunbar, Louisiana, to shuck oysters every winter. EBay still sells "brass pickers' checks," which were tokens that could be exchanged for cash at intervals or exchanged directly for goods at nearby stores. (Photos by Lewis Wickes Hine, 1909 and 1911, Library of Congress, Prints & Photographs Division, LC-DIG-nclc-00749 and 00920.)

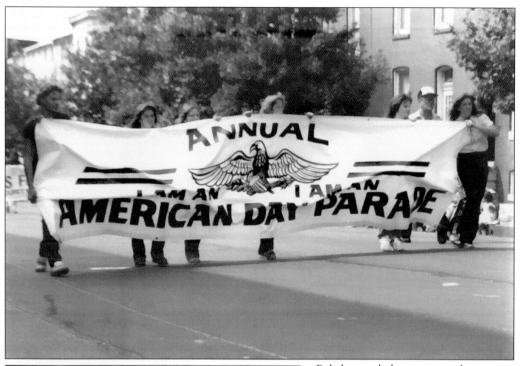

Polish people began to settle in Fell's Point in the 1880s, and by the 1920s, they outnumbered all other ethnic groups. This hardworking, patriotic group still dominates parts of Fell's Point. Pictured here are 1970s scenes from the annual I Am An American Day Parade, honoring newly naturalized citizens. The parade is still held every few years but has moved to Dundalk. (Photos by Mark Anthony Kozlowski.)

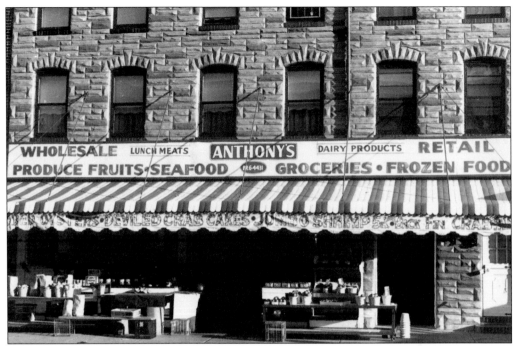

Before the days of the modern supermarket, many fresh fruits and vegetables were sold from horse-drawn carriages by nomadic Baltimore street vendors or "Arabers." John Zadroga started off as an Araber at age nine. In 1946, he and his father bought this building at 2224 Eastern Avenue and started Anthony's. For 55 years, the family-owned grocery lined the sidewalks with produce, filling Fell's Point pantries. Today, most of the local markets have closed, and most Pointers make regular trips to the Safeway in nearby Canton. (Photos by Mark Anthony Kozlowski.)

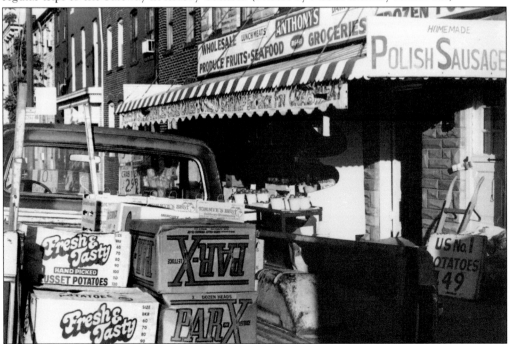

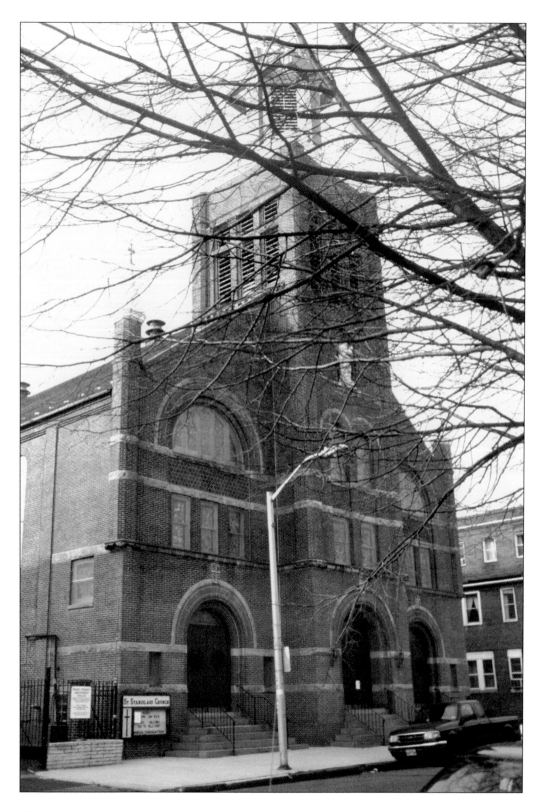

40

A number of Polish organizations continue to actively serve Fell's Point. Pictured above are the Polish National Alliance (PNA) (the large building in the center) and the Kosciuszko Federal Savings Bank (the short building immediately to its right) at 1627 and 1635 Eastern Avenue. Council 21 of the PNA had outgrown its building at 1708 Fleet Street and purchased this one from the Holy Rosary Church, which had been there since 1887. The organization struggled for many years, however, because its older members didn't want to cross Broadway, which was very busy. In the 1970s, the PNA was joined by several other lodges. Today, the upper floors of the building have been converted to senior apartments, and the first and second floors are for PNA activities, including a bar and auditorium. The still-operating Kosciuszko Bank was formed in 1894 by a number of Polish immigrant families who pooled their money to open opportunities for other immigrants.

*Opposite:* For many Polish Catholics, the move from home parishes in the old country into the multiethnic Catholic community in the United States was difficult. Poles wanted to preserve their own language, culture, and religion, and joined together to establish parish churches. The St. Stanislaus Society was formed in 1877 to finance construction of a Polish Catholic church. Their first church was a rented house on the southwest corner of Fleet and Bond Streets. In 1880, a church on Ann and Aliceanna was built. By 1887, it was already overcrowded and spawned the Holy Rosary Parish. The original building had been built on watery, sandy soil, and in 1889, it was demolished, a good foundation laid, and the larger Gothic-style church pictured opposite was constructed. For over a century, "St. Stan's" was a landmark in the community. It grew to include a rectory, a convent, a school, and a cemetery. Times changed, however, and the church closed its doors Easter Sunday in 2000. (Photo by Ruth Gaphardt.)

Isaac Tyson Jr. began mining chromate ore in 1813, and by 1833, he held a monopoly on U.S. chromate mining. He erected the Fell's Point plant in 1845. His sons took it over in 1861 when he died, later renaming it Baltimore Chrome Works. The plant was acquired by Mutual Chemical in 1905, then by Allied Chemical Corp. in 1951. Some of the early studies in the United States of lung cancer and workplace exposure to chromium dust were conducted on Fell's Point workers. In 1985, the plant was closed after the Sierra Club threatened a lawsuit for polluting the Chesapeake Bay. Remediation was complete in 2000 after an investment of over $100 million. Much of the land on Caroline around the Allied Chemical site is still considered "brownfield" by the EPA. (Photo by John Horn.)

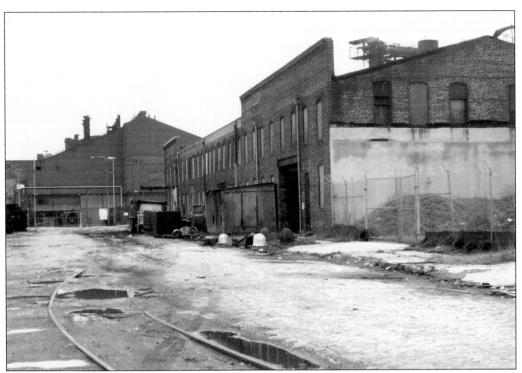

Just east on Philpot from Allied Chemical was the Lacey Foundry. The foundry was originally located in the 1600 block of Thames in one of the buildings where Kali's Court restaurant is now. These photos were taken by John Horn in 1989 on the last day the foundry was open.

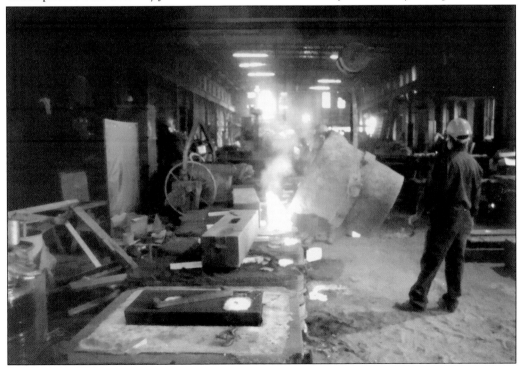

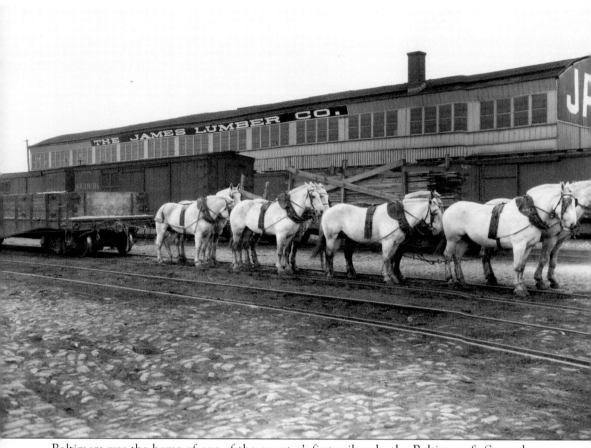

Baltimore was the home of one of the country's first railroads, the Baltimore & Susquehanna, chartered in 1828. Mechanical power didn't appear until the late 1890s, and cars were originally pulled by horses. Because the merchants of Baltimore needed almost door-to-door delivery, a "block route" system evolved in which service was provided by eight-horse teams with a driver and brakeman. For heavy loads, two or even three teams might be lashed together. Horse-drawn railroading continued in Fell's Point until 1917, the year of the photo above. (Photo courtesy of Herbert Harwood.)

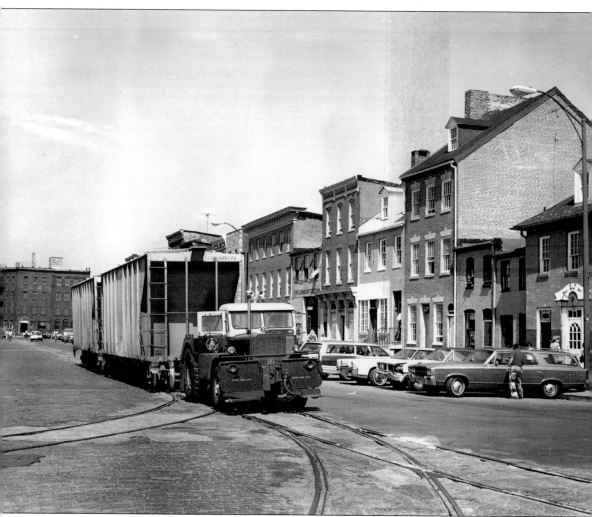

A 1978 article about Fell's Point railroading began with the suggestion that it could easily qualify for an award for "Most Obscure and Oddest Operating Railroad." The railroads here operated on streets laid out in the 18th century with sharp curves and tight track space. A city ordinance prohibited steam-powered locomotives on most streets, and railroads developed a system of rubber-tired gas-electric tractors fitted with railroad couplers and airbrakes. Most of the tracks were laid down between 1860 and 1873 and remained largely unchanged for the next century. In the 1970s photo above, a B&O tractor couples onto two cement cars at the intersection of Thames and South Ann Streets. (Photo by Herbert Harwood.)

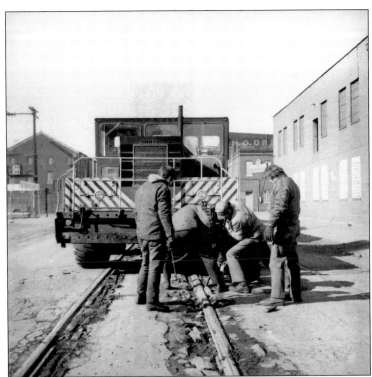

Mishaps were not uncommon on the rough street tracks, which had decomposed over the years. Here, a crew attempts to straighten a buckled rail. One resident remembers a huge snowstorm during which a city snowplow became impaled on a damaged piece of track. The blade had to be taken off and a welder called in to remove it. "After that, the City didn't want to plow Thames Street, which was a problem," the resident said. (Photo by Herbert Harwood.)

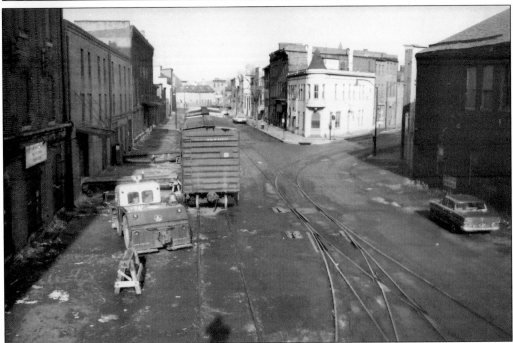

This photo looks north on Fell Street from Henderson's Wharf. In an article entitled "Horse-era railroading at the Harborside," from *Railfan* magazine in February 1978, Herbert Harwood said, "Although still relatively active, the entire area is slipping into the status of a commercial and industrial no-man's land." (Photo by Herbert Harwood.)

Trains continued on Fell's Point streets until the late 1980s. They were not well loved by residents, who complained of being awakened at 2:00 or 3:00 a.m. by the heaving of their engines. Railway cars would sometimes be left to sit for long periods, blocking in vehicles. Once, several young people who were driving in fog ran into one such car and were killed. (Photos by John Horn.)

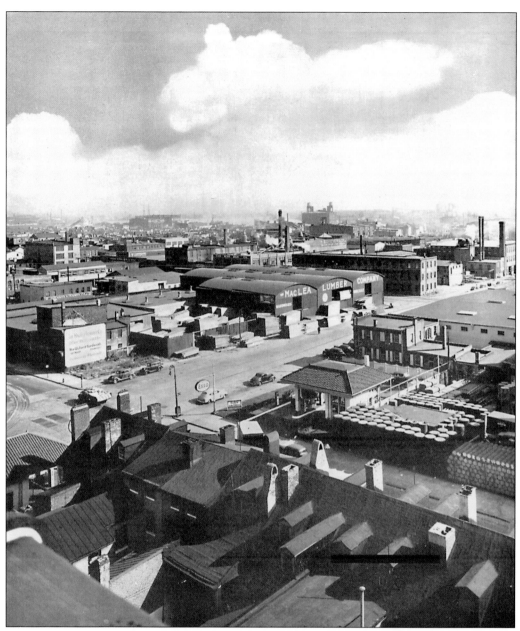

As the city grew, lumberyards became an important part of western Fell's Point. In 1943, the MacLea Lumber Company celebrated its 50th birthday by publishing a book, *Hewing to the Line*, which included this aerial photo of the industrial area to the northwest of what is now the historic district. MacLea was located at 506 South Central Avenue, just south of Eastern Avenue. Very few of the industrial buildings visible in this picture exist today. The houses in the forefront are part of what is today known as Little Italy. In the distance, about one-fourth of the way across the horizon, is Recreation Pier with the B&O Warehouse (now Henderson's Wharf) behind it.

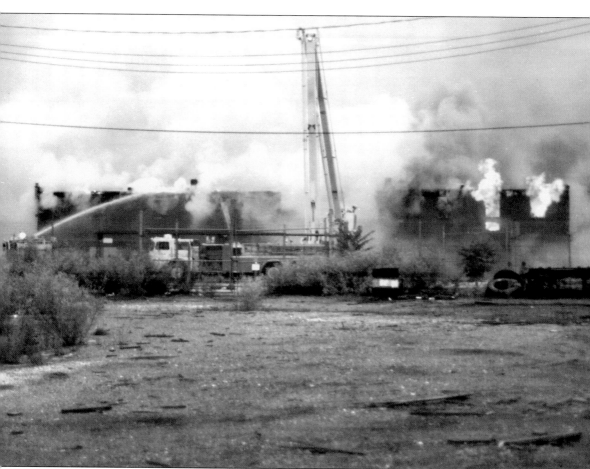

All longtime Fell's Point residents remember spectacular lumberyard fires like the one above, in June 1987. "Developers would buy these old factories and old lumber companies and usually one Sunday a year, one of the properties would burn to the ground, until eventually all the acreage was cleared. . . . I think it happened purposely so that people could tear them down and build more modern, bigger things," said one resident. "No," said another. "The fires happened when the City was trying to clear the land for the road." A third blamed the homeless who often slept in them. A fourth said it was definitely not the homeless; police would typically be seen in front of the buildings the day before and at least once had the street blocked off before the fire even started. (Photo by John Horn.)

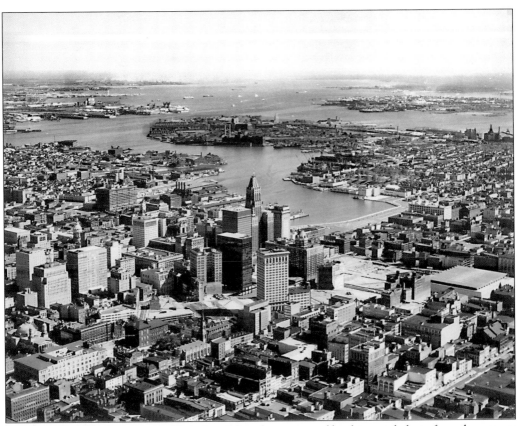

By the 1950s, Fell's Point was highly industrial, as demonstrated by this aerial photo from downtown Baltimore, looking southwest down the Patapsco. The Fell's Point portion of the photo is shown expanded below, with Henderson's Wharf on the far left, followed by Recreation Pier, Terminal Warehouse, Rukert Terminals, and the Allied Chemical buildings. (Photo by M. E. Warren, Annapolis; courtesy of the Preservation Society.)

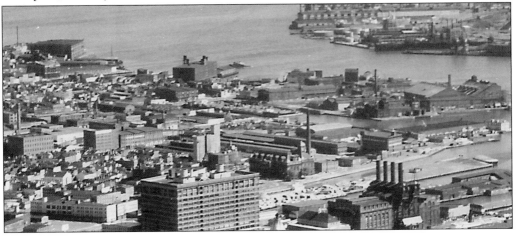

## *Three*

# STOP THE ROAD, SAVE THE NEIGBORHOOD

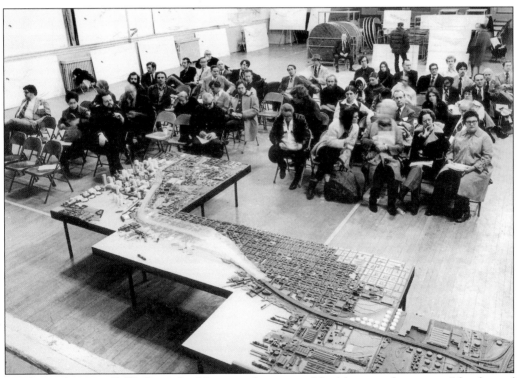

By the mid-1900s, Fell's Point had lost its identity and had become known as "the foot of Broadway." The city considered it a slum and planned to clean it up by using federal highway money to route the East-West Expressway along the harbor. Interstates 70, 83, and 95 would meet in a 16-lane bridge through Little Italy and continue on through Fell's Point. The community meeting above, held during this period, shows a model of the expressway. (Photo courtesy of the Preservation Society.)

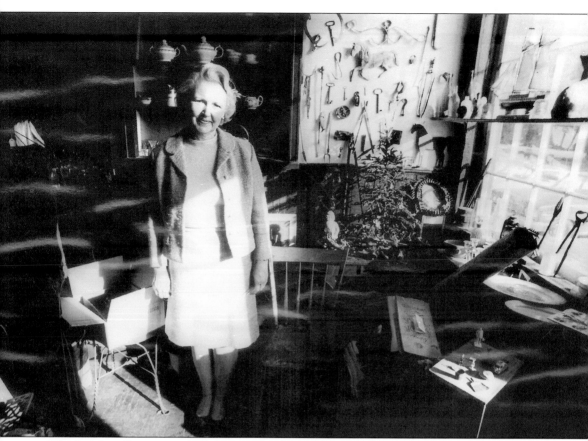

The "road war" was incredibly divisive for the neighborhood. At the time, waterfront property was not sought after, and the area south of Fleet Street was primarily maritime/industrial. Many neighborhood Poles accepted the city's decision without question. A handful of preservationists had purchased and begun to restore some of the neighborhood's historic sea captains' houses. They formed the Society for the Preservation of Federal Hill, Montgomery Street and Fells Point in 1967 to fight the road. Tom Ward was the first bright spot in the seemingly hopeless battle. He had been the only city council member who voted against the expressway and later lost a bid for reelection because of his stand on the issue. Several milestones in the long battle occurred in 1969: first when Fell's Point became Maryland's first historic district on the National Register of Historic Places, and second when Norman Ramsey from Semmes, Bowen and Semmes filed a lawsuit pro bono to test the National Historic Preservation Act of 1966. The photo above shows the Preservation Society's first president, Lucretia "Lu" Fisher, in her Fell's Point shop. (Photo courtesy of the Preservation Society.)

In 1992, the Preservation Society put on a "Founder's Day" party to honor those who had fought "the road." The photo above shows Richard Gatchell giving an award to Lu Fisher while several other officers stand by.

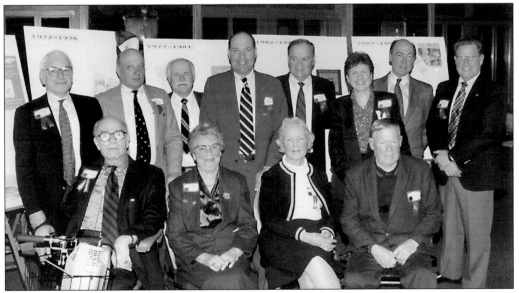

Founders Day Certificates were issued and the recipients photographed. Posing above from left to right are the following: (first row) Jack Gleason, Eleanor Lukowski, Lucretia Fisher, and John Burke; (second row) Robert Eney, William Elder, unidentified, Sen. Julian Lapidis, Judge Thomas Ward, Ginny Reidel, Richard Gatchell, and unidentified. (Photos courtesy of the Preservation Society.)

**# 1363**

STREET __ANN ST.__ NUMBER __804__

1. TYPE OF BUILDING (Check more than one if combination)
   Residence ■ Store ☐ Tavern ☐ Warehouse ☐ Other __CIRCA 1790__

2. MAIN CONSTRUCTION  A. Number of storeys: 1☐ 1½☐ 2☐ 2½☐ 3☐ 3½☐ 4■ ☐
   B. Width ____ ft., Depth ____ ft.   C. Roofline: Pitched ☐ Flat ☐ Other _____
   D. Material: Clapboard ☐ Beaded Edge Board ☐ Shingle ☐ Formstone ■
            Brick ■ ; Bond: English ☐ Flemish ■ Common ☐ Running ☐
   E. Cornice: None ☐ Brick ☐ Wood ■   F. Belt Course: Yes ☐ No ■
   G. Watertable: Yes ☐ No ■   H. Entrance steps: Wood ☐ Stone ☐ Brick ☐ None ■

3. WINDOWS  A. First storey: 1■ 2☐ 3☐ 4☐ Storefront☐
   B. Second storey: 1☐ 2■ 3☐ 4☐   C. Third storey: 1☐ 2■ 3☐ 4☐
   D. Window Description
      Lintel: Brick ☐ Stone ☐ Wood ☐ ; Flat ☐ Arched ☐ Flat Arched ☐ Keystone ☐
      Frame: Wide Plank (2½ in. or more)☐ Narrow ■ Beaded ☐
      Shutters: Yes☐ No■   Reveal: ____ inches   Lights: __|__ over __|__
   E. Window variations: If varieties other than described above occur, describe them
      here.

   F. Dormers: 1■ 2☐ 3☐ ; Shed ☐ Pedimented ■ Other _____
      Frame: Pilasters ☐ Plain ■ ; Arched or rounded window ☐

4. DOORS  A. Main Entrance: Casing: Pilasters ☐ Plain ☐ Pedimented Cornice ☐
            Number of door panels ____ . Overdoor: Rectangular ☐ Fanlight ☐
   B. Secondary entrance: Yes ☐ No ■ ; Frame:Pilasters ☐ Plain ☐
      Number of door panels ____ .  C. Cellar door; Yes ☐ No ☐
   D. Alleyway: Yes ☐ No ■ ; Door: Solid ☐ Barred ☐ ; Overdoor: Open ☐ Barred ☐
                                                           Flat ☐ Arched ☐

5. PHOTOGRAPHS
   A. Front view - number _____
   B. Record numbers of other photos with brief description: _____

6. SURVEY TEAM:                    7. ADDITIONAL NOTES:
   _R J Gleason_____

   _____

   _____            DATE: _____

The National Register of Historic Places, authorized under the National Historic Preservation Act of 1966, is the official list of cultural resources worthy of preservation. Fell's Point's acceptance onto the National Register would prevent the use of federal highway money on an expressway through the area. Getting there was a massive effort. Teams of people photographed and surveyed all the buildings in Fell's Point. Above is an example of the survey forms submitted. Opposite are additional examples of the photos. Robert Eney described the acceptance process: "Anne Parrish, who worked for Agnew, took the forms that we had filled out, she took it to Agnew and he sent them over to Dr. Garvey at the Department of the Interior. And in 3 days, we were on the National Register. And the City of Baltimore went crazy."

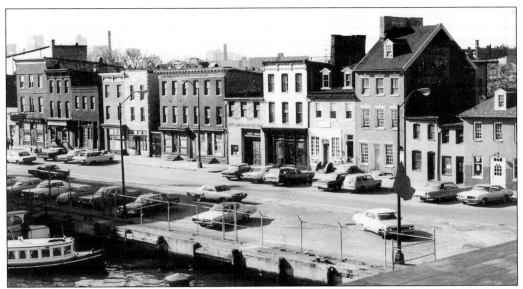

The National Register submission is no longer available. The Preservation Society's copy was burned in a fire, and the Maryland Historical Trust told Robert Eney they have nothing on file. A few pages of photos and most of the negatives can still be found in Preservation Society files. Some of the survey team members, like Eney, kept copies of their work. (Photos and document courtesy of Robert Eney and the Preservation Society.)

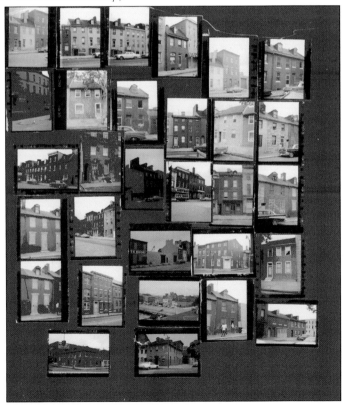

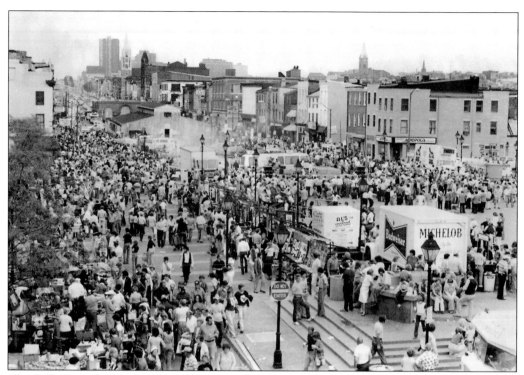

The Fell's Point Fun Festival was begun in 1966 by the Preservation Society to raise funds and draw attention to Fell's Point. The annual festival continues, providing operating funds for the society in its continual battle to preserve the area's historic buildings from demolition. Pictured above is Broadway Square looking north during the 1971 festival. Below is Fell Street viewed from the balcony of Recreation Pier. (Photos courtesy of the Preservation Society.)

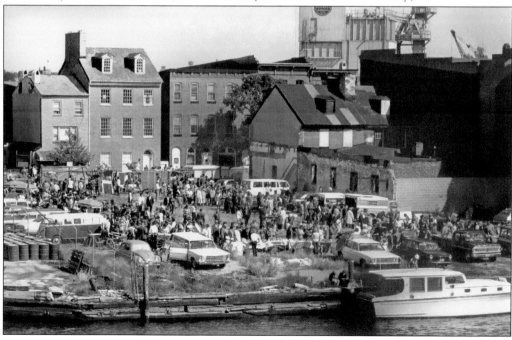

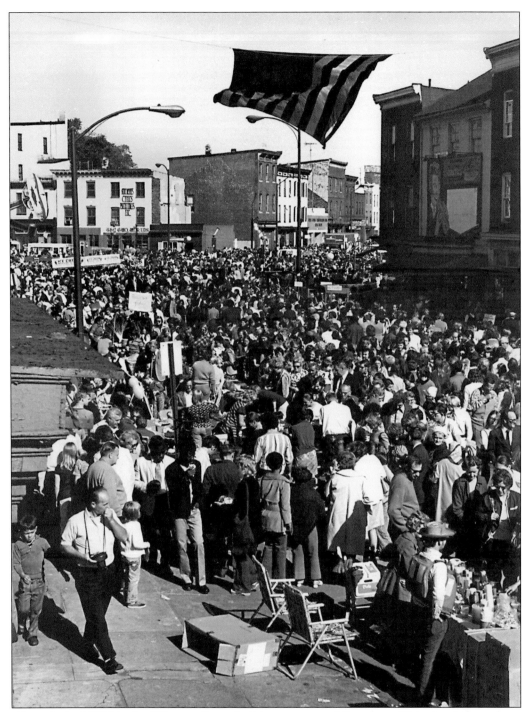

Above is the 1600 block of Thames Street looking east toward Broadway. This view is from about the same location as the one on page 27, but it was taken 40 years later during the festival. (Photo by Lawrence M. Irvine.)

LEWIS.
WESTMINSTER, MD.

Two of the remaining examples of the city's earliest building style can be found at 612 and 164 South Wolfe Street. Constructed in the late 1700s, these small, one-and-a-half-story frame houses represent the lower end of housing available to late-18th- and early-19th-century dwellers. Some experts have argued that they represent the earliest precursor of the Baltimore row house. The Preservation Society is leading an effort to stabilize, rehabilitate, and interpret the two houses, once owned by the Dashiell sisters. They will be called the Two Sisters' Houses.

*Opposite:* The Dashiell family has been deeply rooted in Fell's Point history for 200 years. Capt. Henry Dashiell and his wife, Mary Leeke, built a house at 700 South Broadway at Aliceanna Street in 1796 (now Armadillo's Restaurant). Sisters Eleanor Marine Dashiell (1906–1985) and Mary Leeke Rowe Dashiell (1910–1993) began a museum in 1957 at 807 South Broadway that later became the Fell's Point Museum and Cultural Program, Inc., a collection of historic properties, log books, diaries, captain's gear, books, and paintings of family members by Alfred Miller and Rembrandt Peale. The sisters were among the earliest members of the Preservation Society and the group that began the Fell's Point Fun Festival to "stop the road." Here the two sisters are shown with their mother, Amelia Eleanor Marine Dashiell. Amelia was one of the group of Baltimore women called the "four horsemen" because of their aggressive lobby of Congress in the 1920s and early 1930s to have the "Star Spangled Banner" chosen as the national anthem. (Photo courtesy of John Patton Mende, President of the Board, Fell's Point Museum.)

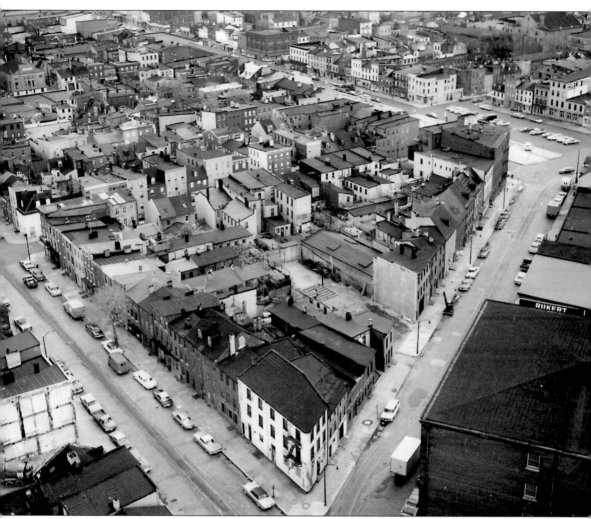

Pictured above is the portion of the Fell's Point Historic District bounded by Bond, Thames, and Broadway during the time of the road battle in the 1960s and 1970s. Since then, Broadway Square (upper right) has been redesigned. The Terminal Warehouse on the lower right has been replaced by Bond Street Wharf. Some of the Brown's Wharf/Rukert Terminal buildings, barely visible above the Terminal Warehouse, have also been replaced. Parking on Bond Street has been reconfigured. A substantial number of individual buildings have been renovated. (Photo courtesy of the Preservation Society.)

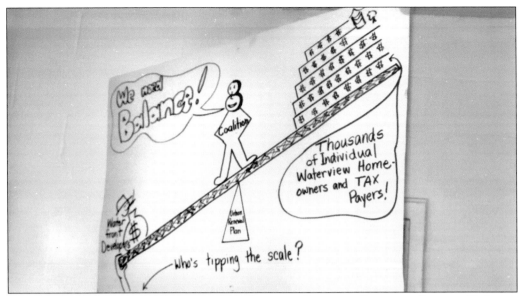

The Preservation Society's director of development, Romaine Sommerville, says: "Life is a constant battle down here. In 1975 the urban renewal ordinance was written after the road fight to help people redevelop this area. But what's happened is, every speck of the land is not only being developed to densities which were considered extremely generous in 1975, but everybody is getting variances. We've been in something like 300 meetings and hearings trying to get the reasonable density and height restrictions on the new development. We are going to be completely surrounded with high-rise buildings."

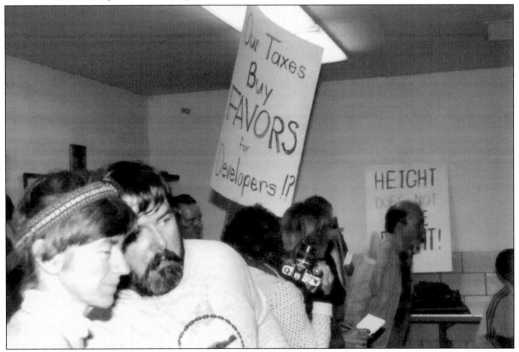

In this picture, Waterfront Coalition's Carolyn Boitnott (left) attends a meeting on building height. (Photos by John Horn.)

The Robert Long House at 812 South Ann Street, built c. 1765, is considered the oldest existing residence in Baltimore. According to Thomas W. Griffith in the *Annals of Baltimore* (1833): "In 1764 Mr. Robert Long, who, it is said had persuaded Mr. Fell to lay off that part of the town, commenced some improvements at the corner of Ann and Thames Streets, moved to the country and left his building unfinished."

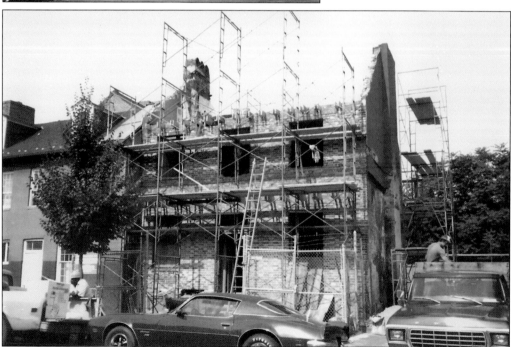

The photo at the top of the page, taken in the 1970s, shows the Robert Long House before restoration. It was three stories high and was coated with "flint coat," a coating of tar and a little granite. The bottom photo is during the restoration. (Photos courtesy of the Preservation Society.)

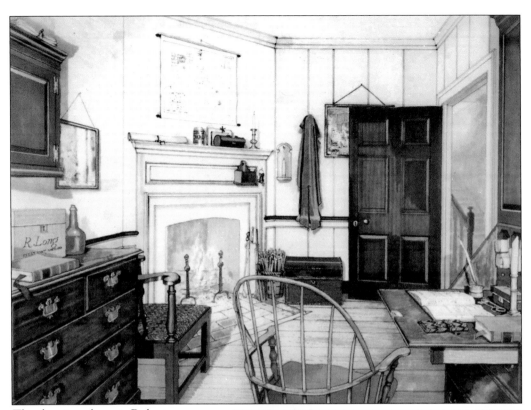

The drawing above is Robert Eney's rendition of the drawing room of the Robert Long House when it was first built.

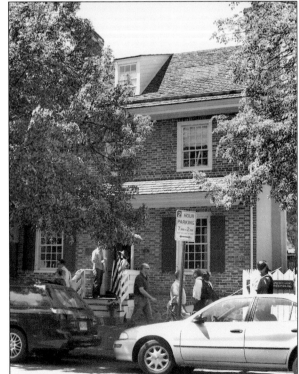

Today, the Robert Long House has been restored and is furnished with period antiques. It contains the offices for the staff of the Preservation Society. The house and garden are open for tours daily.

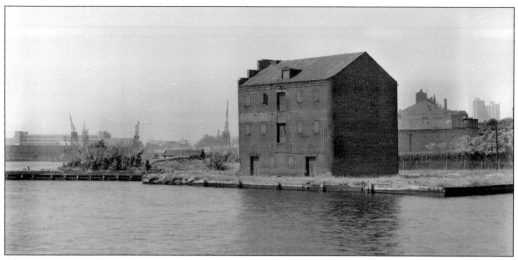

The Levering Coffee House on Chase's Wharf at the foot of Caroline Street was built c. 1806 and is the oldest remaining industrial building on the waterfront. The building was the site of one of the early incidents in the Civil War, when the ship *Fanny Crenshaw* flew a secessionist flag. The building caught fire in the early 1990s, and the top floors were burned. In 2003, the Living Classroom Foundation began stabilizing and restoring it as part of the Douglass-Myers Maritime Park. It will house education and visitor space as well as a historic ship repair workshop. (Photo by Louise Taft, 1985, Library of Congress, Prints & Photographs Division, HAER MD-60.)

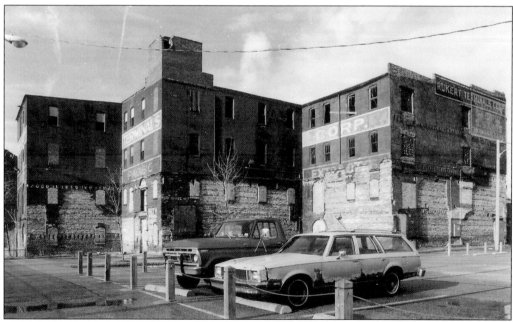

In the 1990s, several developers wanted to clear the remaining empty waterfront warehouses to make room for new development. The Rukert Terminal warehouses above were sacrificed to community representatives in order to save the London Coffee House, George Wells House, and Chase's Wharf property. (Photo by Anne Gummerson, 1997.)

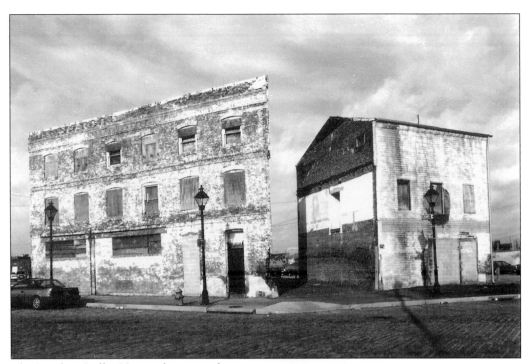

The London Coffee House, shown on the right above, was built in 1770 by John Cantrel and is believed to be the oldest commercial structure in Fell's Point. The back of the building before restoration is pictured at right. The shipbuilder George Wells built his combination home and inn, shown above on the left, around the corner on Thames Street, across from his shipyard. The George Wells House and London Coffee House became symbols of the battle to save Fell's Point, first from the East-West Expressway and later by unscrupulous developers who believed that the community's historic structures were worth more torn down than standing. (Photos by Anne Gummerson, 1997.)

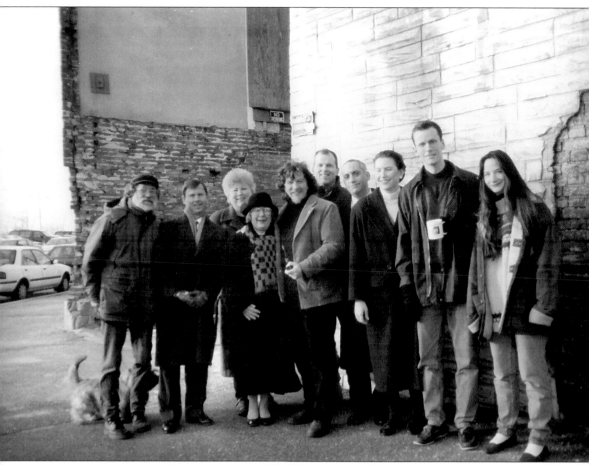

In 1998, according to Romaine Sommerville, "Constellation Properties was making an exchange with the City, in which parking lots throughout the west side were being exchanged for Chase's Wharf which the City then gave to the Living Classrooms. Constellation came to a community meeting and said that if we would go along with this exchange, they would not demolish the George Wells House and the London Coffee House. So everybody went along with it. On Friday, PJ's walking his dog and the dog ran behind the properties and there were two enormous signs posted on the buildings that they would be demolished in 48 hours. When we called Constellation they said 'oh that wasn't them—the buildings were in such poor condition the City decided to condemn them.' So we ran around all weekend getting the condemnation notices lifted, and then we were given a very short period of time to purchase the buildings and stabilize them." Pictured above, from left to right, is the group that saved the buildings: Pastor Jack (P. J.) Trautwein and his dog Duffy, Kent Johnson of Constellation's Baltimore Gas & Electric Co., Denise Whitman, Romaine Sommerville, Steve Bunker, Dan Winner, Perry Sfikas, Jennifer Etheridge, David Davighi, and Avril Haines. (Photo courtesy of the Preservation Society.)

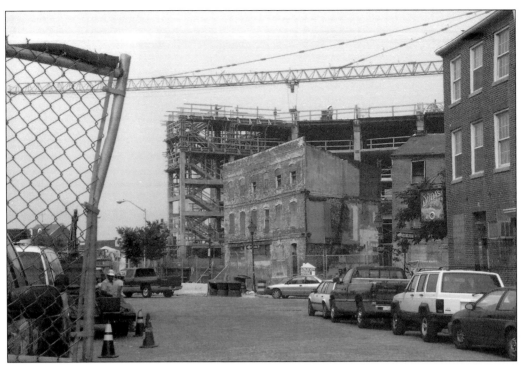

This July 2002 photo shows the parking garage, fronting on Thames Street, being erected around the two historic buildings.

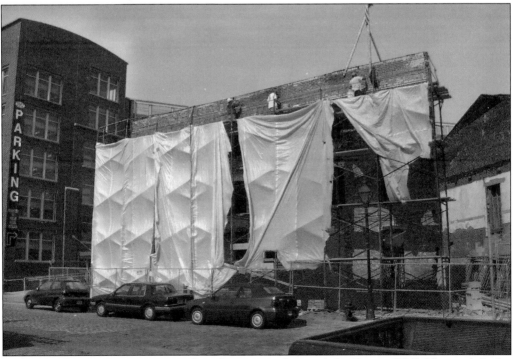

In this April 2003 photo, coverings have been erected around the George Wells House while the brick is being tuck-pointed.

The building at 1724 Thames Street was originally a horse-drawn trolley barn that ran all the way from Thames to Lancaster Street. A landmark on the water since the mid-19th century, the block-long building later became a warehouse for paper stock, metals, iron, and rope (painted prominently on its front). Steve Bunker's China Sea was located there from 1983 until 1991. When the China Sea moved to Ann Street Wharf, it was replaced by the Daily Grind coffee shop. The Orpheum art movie house occupied the second floor during much of the 1990s. (Photos courtesy of the Preservation Society.)

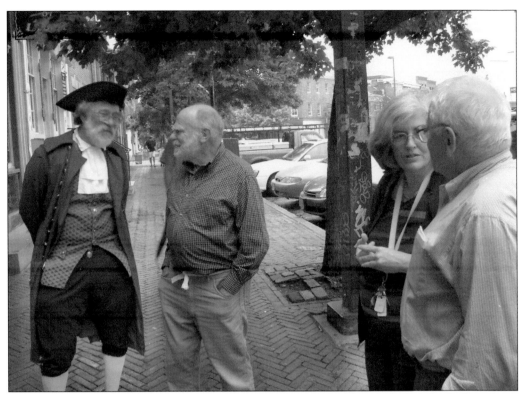

The building was designed to be part of a Maritime Center that included the Robert Long House and the Visitor Center (diagram below). The Maritime Museum opened in June 2003. Pictured above at the opening, from left to right, are Jack Trautwein, in his town crier costume, historian Geoffrey Footner, Preservation Society director Ellen von Karajan, and architectural historian Robert Eney.

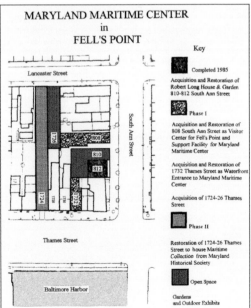

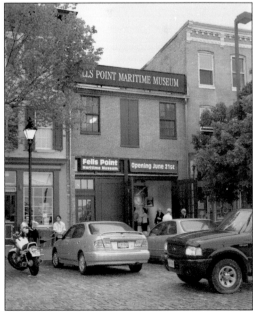

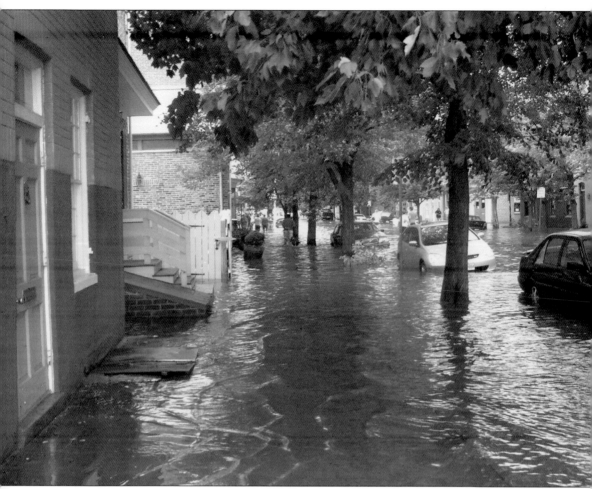

Over time, several disasters have damaged or destroyed priceless photographs and archives maintained by the Preservation Society. In 1999, the building caught fire, causing substantial damage to the interior and its contents, including irreplaceable historic photographs and documents. In 2003, Hurricane Isabel, the worst since 1938, blew a 10-foot tide into Fell's Point. The Robert Long House lost its furnace, water heater, and electrical panels. Doors warped and mortar crumbled. A number of shards, the residue of archaeological digs, became wet when the basement flooded.

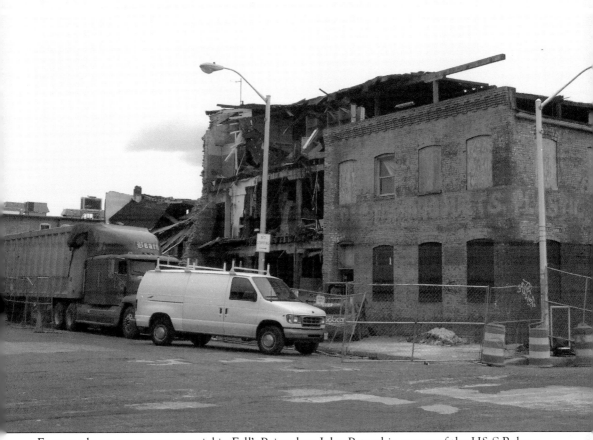

Few people are more controversial in Fell's Point than John Paterakis, owner of the H&S Bakery, which occupies the blocks between Aliceanna, Caroline, Fleet, and Bethel Streets. In May 2002, H&S announced that it needed to move its truck-loading operations from Fleet Street to Caroline, closing off the 600 block of Dallas Street and demolishing a series of warehouses on Caroline. The neighborhood argued that closing Dallas would cut off residents to the north, reducing property values. Preservationists fought for the 18th-century art deco P. T. O'Malley lumber warehouse at Caroline and Aliceanna. Dallas was closed off anyway, but the O'Malley warehouse was spared. The demolition of the buildings around the warehouse is pictured above. "We didn't 'win'—Paterakis threw us a bone," said one resident, who keeps a list of Paterakis quotes. As of 2005, the trucking operation remains on Fleet; Dallas is closed and is being used for parking. Paterakis's money did help fund the restoration of the E. J. Codd building just to the south, after it was damaged during Isabel and almost demolished.

The buildings above were the family home and dairy building of German immigrant Julius Wills at 2016–2026 Fleet Street. The unusual art deco dairy building, built in 1927, was one of the last remaining examples of an industrial building created by an immigrant in the Fell's Point neighborhood and one of less than a dozen surviving examples of early-20th-century industrial architecture. It was structurally sound and historically important but difficult for adaptive reuse because of its design. In 2004, the developer who owned the buildings filed for a demolition permit from the City to build modern town homes. The City granted permission, and demolition began on the roof of the adjacent Wills home on May 17 (the missing roof is visible on the far left). The Preservation Society filed for a restraining order, which was granted, but lost in the final hearing and had to pay the developer's costs for the nearly two-month delay.

*Four*

# THE WATERFRONT
## *Then and Now*

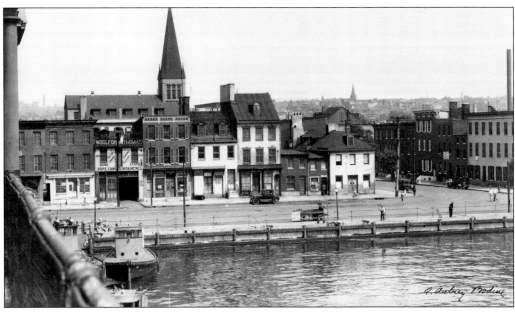

The 1700 block of Thames Street is probably the most photographed streetscape in Fell's Point. It also demonstrates the waves of change that continue to rock Fell's Point as it recovered from the road battle, became increasingly gentrified, and is now being surrounded by new high-rise office and condominium developments. This famous 1930 photo was taken from the deck of Recreation Pier, which in the 1990s was the set for the television series *Homicide: Life on the Street*. The spire on the horizon is St. Stan's Church, built by Polish immigrants in 1880, which is now closed. The tall building in the center is 1732 Thames Street, an early-19th-century merchant's residence and shop, purchased by Lucretia Fisher when she set off the "road battle" to save Fell's Point from the freeway. (Photo by A. Aubrey Bodine, © Jennifer Bodine.)

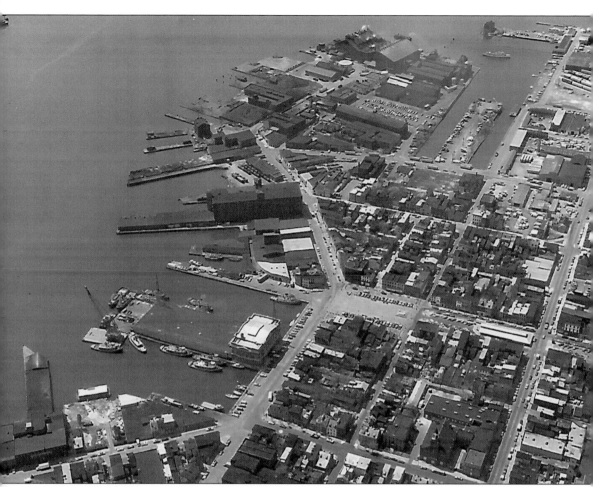

This 1980 aerial view of the Fell's Point waterfront looking west shows Recreation Pier in the lower left, followed by Broadway Pier, Brown's Wharf, Terminal Warehouse, several other piers, and the Allied Chemical site. The Terminal Warehouse was a six-story brick building that was a fixture on the Fell's Point waterfront from the early 1900s to 1992, when it was taken down. It was replaced by Bond Street Wharf in 2002. According to developers Struever Bros. Eccles & Rouse, Inc.: "Its owners at Constellation determined it was not feasible to recycle, in part because it didn't have many windows. With the success of the Digital Harbor, its high-ceilinged loft spaces probably would have succeeded in luring office tenants with or without extra windows—a sad irony that won't help bring it back today." Bond Street Wharf was designed using the Terminal Warehouse as a starting point. (Photo by David Clark & Associates.)

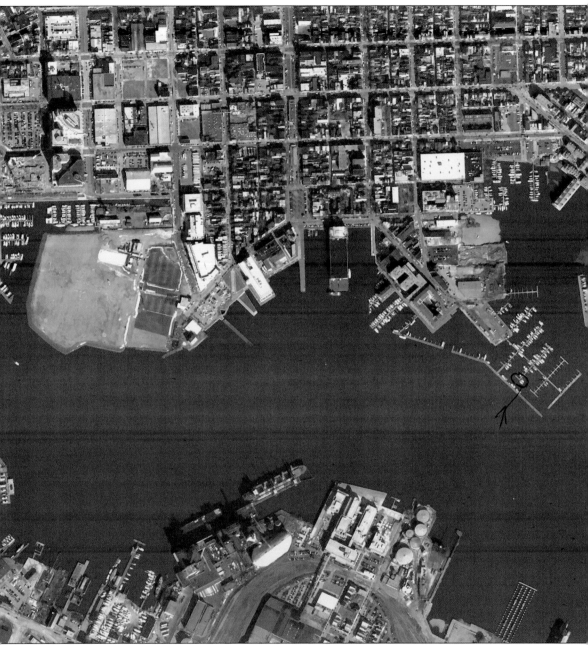

This recent satellite image by AirPhoto USA, looking north, shows the Fell's Point waterfront with the now-empty Allied Chemical site (far left in the center). Bond Street Wharf, the white building on the waterfront, has replaced Terminal Warehouse. Brown's Wharf looks entirely different. Broadway Pier has been rebuilt. Only Recreation Pier is relatively unchanged. To the right, Fell Street branches off of Thames Street to the southeast with Henderson's Wharf and its marina at the end. At the bottom of the satellite image is Locust Point, with Domino Sugar on the left and Tide Point on the right.

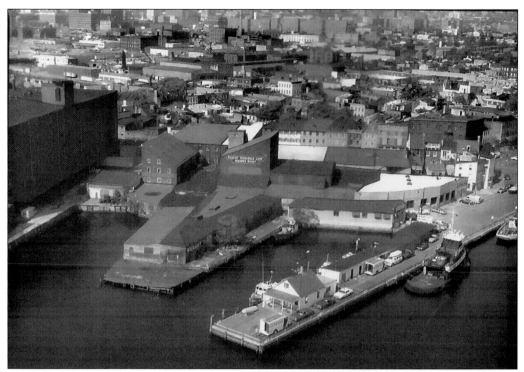

In 1980, Broadway Pier housed the maritime police office and Vane Brothers' offices. Rukert Terminals owned Brown's Wharf, which had an enclosed pier complex in front of it on the water. The pier is rumored to have once contained a slave holding and trading room. (Photo by David Clark & Associates.)

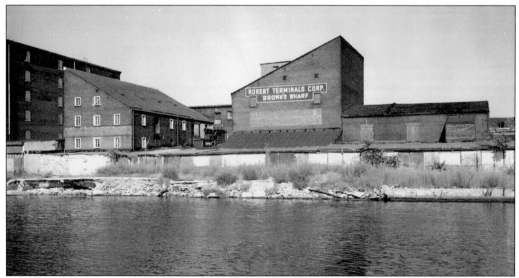

Brown's Wharf was built by George Brown, son of Alexander Brown, an Irish immigrant and founder of a brokerage firm. The last coffee clipper ship was unloaded at Brown's Wharf in 1890. By 1960, Rukert had acquired all the property. In this 1985 photo, the pier complex in the top photo has disappeared. (Photo by Louise Taft, 1985, Library of Congress, Prints & Photographs Division, HAER MD-61.)

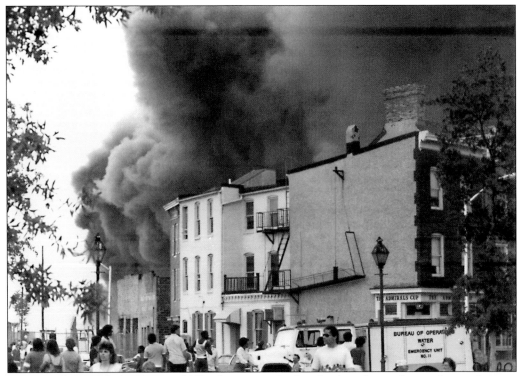

In September 1986, the Terminal Warehouse caught fire. In this photo, the smoke can be seen pouring through the buildings at the base of Broadway Pier.

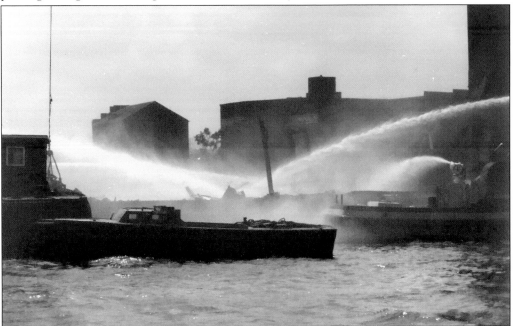

Here, fireboats and engines succeed in putting out the blaze after extensive damage to the buildings. Terminal Warehouse was also the site of a fake fire for the filming of Barry Levinson's move *Avalon*. (Photos by John Horn.)

Above is a close-up of the maritime police station at the end of Broadway Pier in 1985. The police station was visible in the aerial photo on page 76. (Photo by John Horn.)

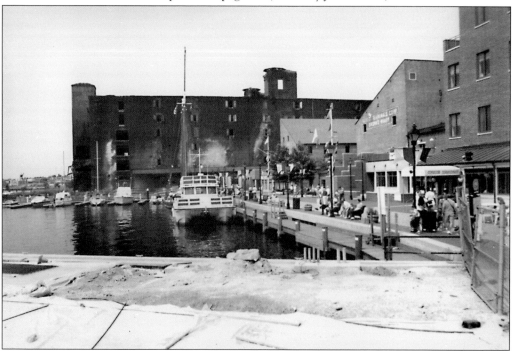

In this 1992 photo looking west, Broadway Pier (in the foreground) is being rebuilt. Brown's Wharf (on the right) opened in 1986, and water taxis and recreational boats have begun visiting. Burned-out Terminal Warehouse is still visible in the background. (Photo by John Horn.)

Today, Broadway Pier has no buildings on it, and its brick promenade is a place where tourists amble, reading the names inscribed in the bricks. Often, visiting vessels berth here, such as the German battleship *Brandenburg*, which visited in June 2004.

Brown's Wharf is mostly offices, as is Bond Street Wharf at the back of the photo above. A restaurant is on the corner on the right with plenty of outdoor seating in good weather.

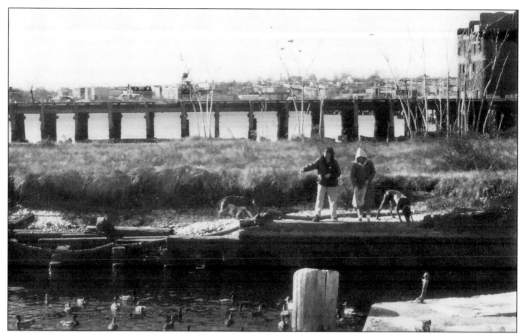

The 1994 photo above shows the Levering Coffee House in the distance with its roof burned off. Several people and their dogs stand on the old pier at the foot of Bond Street in the foreground. The pier in the middle is the location from which the first frigate, *Virginia*, was launched from the George Wells Shipyard in 1776.

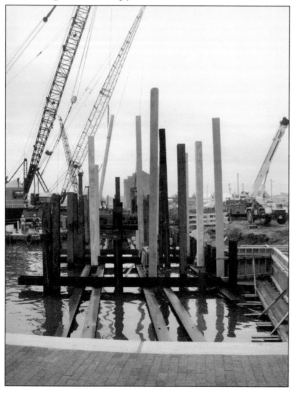

The old pier at the foot of Bond Street is now gone, replaced by a new sea wall and modern pier called Bond Street Landing. The photo here shows the sea wall and pier being constructed in 2003.

The posts in the pier at the end of Terminal Warehouse were pulled up in 2002 after Bond Street Wharf was completed. In the photo on the right, the old pier at the foot of Bond Street is visible, covered with weeds and construction rubble.

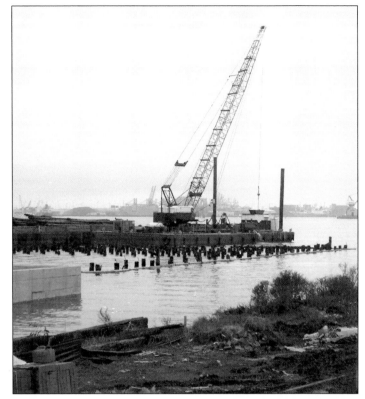

Today, Bond Street Landing has replaced the old pier on the Fell's Point waterfront. The photo below shows the park and pier from the corner of Bond and Thames Streets looking south.

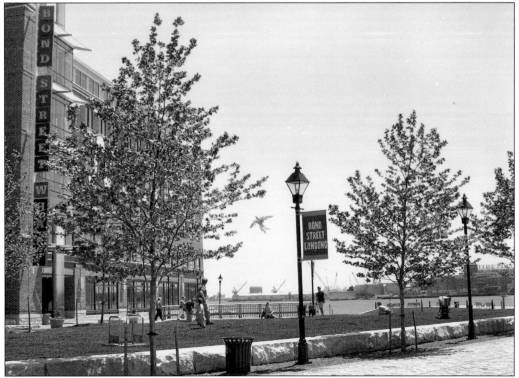

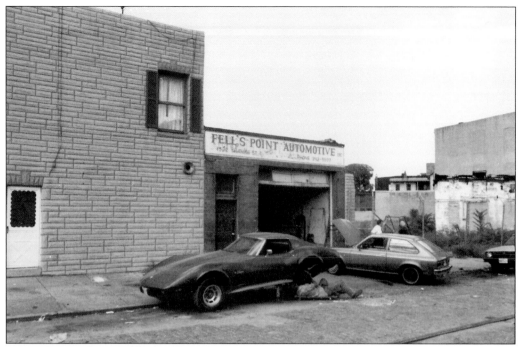

By 1986, a number of older buildings had already been torn down, and Fell's Point Automotive was the highlight of the 1500 block of Thames Street. The back side of the George Wells House is barely visible on the right. (Photo by John Horn.)

Today, this block has changed dramatically. The building above has storefronts on ground level, urban town homes on the upper levels, and a large parking garage built into the interior of the block. The George Wells House is on the far right, followed by Bond Street and Duda's.

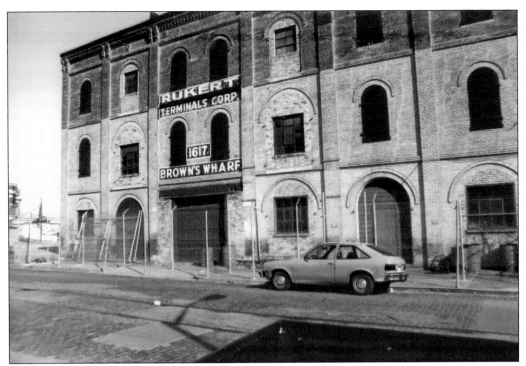

In May 1987, Brown's Wharf, as viewed from Thames Street, was empty and fenced off. Many of the neighboring buildings had been torn down, leaving huge gaps along the 1600 block of Thames. In the photo above, Recreation Pier is barely visible on the far left. (Photo by John Horn.)

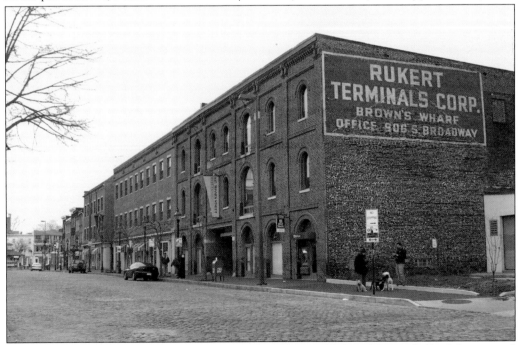

Today, the same block has a series of additional buildings added to the east (left) of the original Rukert Terminal building to form the Brown's Wharf office and shop complex.

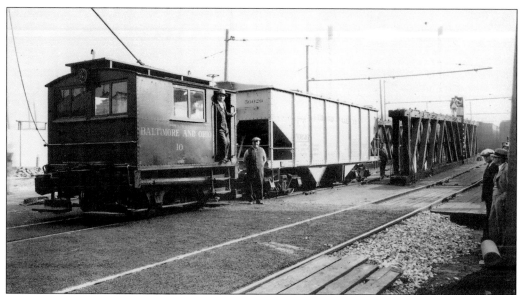

Pictured above, in about 1932, are B&O Railroad cars at the transfer bridge entry to the car float near Henderson's Wharf Warehouse at the foot of Fell Street. The car float was the only way to transport railcars across the Patapsco, and it was critical to connecting East Baltimore with the Western states. (B&O Railroad photo courtesy of Herbert Harwood.)

What is today known as Henderson's Wharf was originally O'Donnel's Wharf. The wharf was used for launching steamships, such as *The Somerset* in 1865. That tradition continued through 1929, with the launching and operation of Lykes Lines. The current building was completed by B&O in 1897 and was used for tobacco storage for 30 years, then automobile tires for 10 years, then foreign cars, glass, and whiskey bottles. (Photo by Jean P. Yearby, 1985, Library of Congress, Prints & Photographs Division, HAER MD-51.)

The old B&O warehouse building burned in 1984. It was completely renovated and opened in 1991 as a multi-use complex with apartments and hotel rooms and special function space. Remodeling was again required after it was flooded by Hurricane Isabel. Today, the Inn at Henderson's Wharf is one of Baltimore's highest-rated hotels. On its upper floors are 129 distinctive apartment homes. It also offers a marina and conference center. (Photos below by Anne Gummerson.)

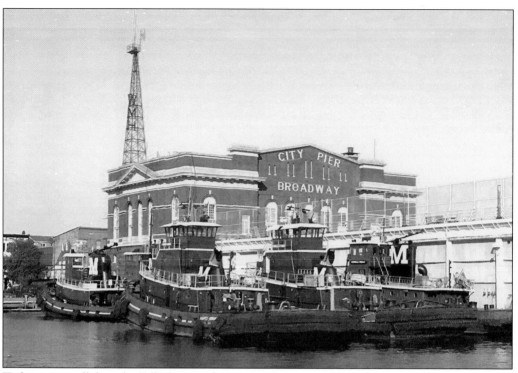

Today, some still describe Fell's Point as being a working port. The community zealously supports the presence of the tugs at Recreation Pier, and all future uses of that landmark building have been contingent on allowing Moran Towing to remain.

Others say the "working port" today, from Fell's Point to the Inner Harbor, is really the educational tourism industry. Above, a group of students learn about the Chesapeake Bay ecosystem from Living Classrooms aboard the *Lady Maryland*. (Photo by Anne Gummerson.)

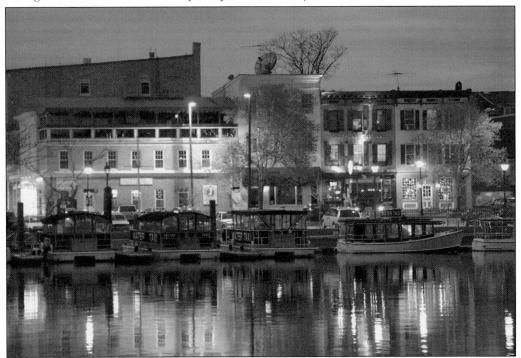

Above, water taxis dock on Thames Street next to Broadway Pier, ready to take passengers to Inner Harbor, Canton, and Fort McHenry.

Each year in October, Sail Baltimore sponsors the Great Chesapeake Bay Schooner Race to promote public awareness of the Chesapeake Bay's maritime heritage and to encourage the preservation and improvement of the Chesapeake's natural resources. The schooners do a parade of sail through Inner Harbor then dock in Fell's Point the night before the race. The Whistling Oyster is the message center and hosts the pre-race skipper's meeting.

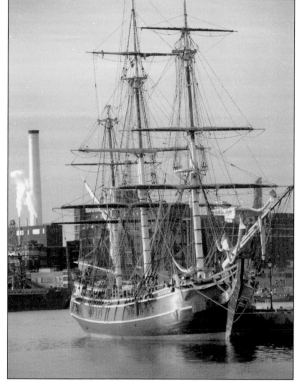

A major benefit of living or working in Fell's Point is walking by Broadway Pier to find out whether a visiting vessel is docked there. Visitors range from working tugs to huge battleships to tall sailing ships. At right is the HMS *Bounty*, docked here in 2003. The Canton Kayak Club also has one of its kayak rafts tied up nearby off Brown's Wharf.

Old timers talk about the days when people could jump in for a swim from Broadway Pier. For many years, the harbor water was so polluted that this was unthinkable. Today, the water is much cleaner, and schools of fish are often visible during warmer months. It is not unusual to see someone crabbing or fishing, although the amount of seafood one should eat from Baltimore Harbor is questionable.

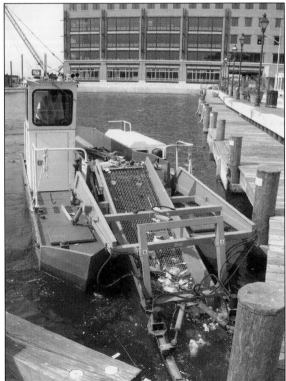

When thinking of a garbage vehicle, normally one thinks of a land-based vehicle, but Baltimore City also has garbage boats or trash skimmers (at left). Living Classrooms students are sometimes seen in small boats helping to clean up trash in the water. The Baltimore Harbor Watershed Association has recently been formed to help prevent storm sewer trash from entering the harbor in the first place.

As was the sea in Fell's Point's early history, the waterfront today is not always friendly. In 2003, the storm of the century, Hurricane Isabel, blew a 10-foot tide up Baltimore's harbor, flooding the lower-lying areas of Fell's Point and Canton and putting Inner Harbor's World Trade Center out of business for months. Above, a bicyclist crosses floodwaters on Lancaster at Caroline Street.

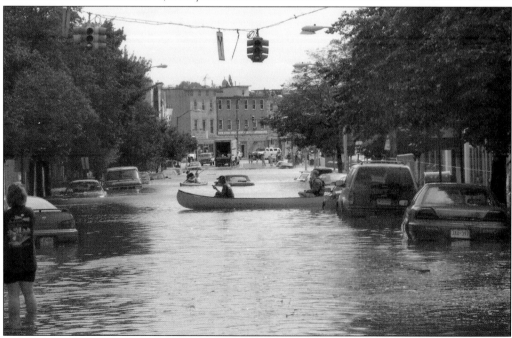

Luckier residents enjoyed the diversion, kayaking through the streets and stopping at bars whose signs read "Isabel Who?" Those less fortunate lost cars and were forced out of their homes for months or, in some cases, years. Above is the view at Wolfe and Aliceanna the morning after Isabel.

# Five

# PEOPLE SHAPE THE COMMUNITY

While it is the buildings that one often remembers after visiting a place, it is the leadership, imagination, and perseverance of often uncelebrated individuals that build the place, shape its history, and fight to decide its future. Commo. Joshua Barney (1759–1818), often forgotten today, was one of the most famous officers to sail out of Fell's Point. Born near Baltimore, he took charge of his first vessel at age 14 and was the only officer to win acclaim in both the American Revolution and the War of 1812. He took part in 35 Revolutionary War naval engagements and was imprisoned three times. Fell's Point ships he captained included the *Virginia*, the *Wasp*, the *Hornet*, and the *Federalist*.

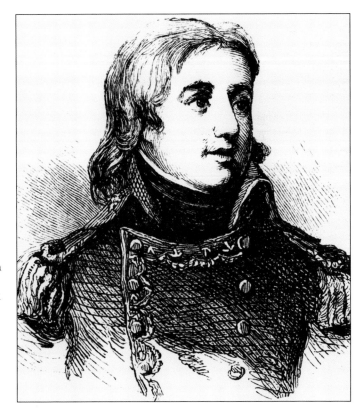

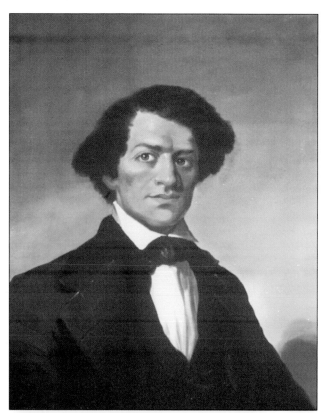

Frederick Douglass (1818–1895) was one of Fell's Point's most famous residents. He was sent here in 1826 as a slave and worked as a ship's caulker for several years. He periodically resided in Fell's Point as a slave until he escaped to freedom on September 3, 1838. Once free, Douglass became an orator, author, and outspoken critic of slavery. (Painting by Elisha Hammond.)

Below are Frederick Douglass's great-great-grandson, Frederick Douglass IV, and his wife, B. J., in front of the Robert Long House. The couple portrays Frederick Douglass and his wife, Anna, around the country, seeking to empower black youth. (Photo courtesy of the Preservation Society.)

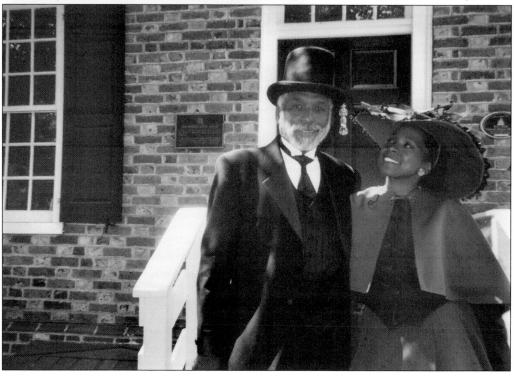

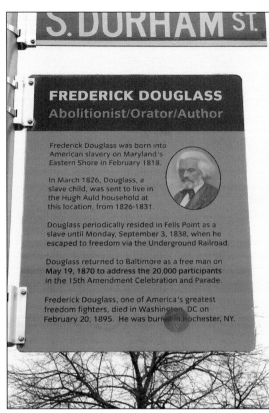

**FREDERICK DOUGLASS**
Abolitionist/Orator/Author

Frederick Douglass was born into American slavery on Maryland's Eastern Shore in February 1818.

In March 1826, Douglass, a slave child, was sent to live in the Hugh Auld household at this location, from 1826-1831.

Douglass periodically resided in Fells Point as a slave until Monday, September 3, 1838, when he escaped to freedom via the Underground Railroad.

Douglass returned to Baltimore as a free man on May 19, 1870 to address the 20,000 participants in the 15th Amendment Celebration and Parade.

Frederick Douglass, one of America's greatest freedom fighters, died in Washington, DC on February 20, 1895. He was buried in Rochester, NY.

Today, Frederick Douglass is celebrated in Fell's Point. A sign, at right, marks the home on Durham and Aliceanna where he lived with the Hugh Auld household from 1826 to 1831. A second sign on Lancaster and Wolfe, below, marks the site of the Asa Price shipyard where he learned the caulking trade and worked on the ships being built in Fell's Point. A third sign on Dallas and Fleet marks Douglass Place, the series of houses for low-income neighborhood residents that he built when he returned here in later years.

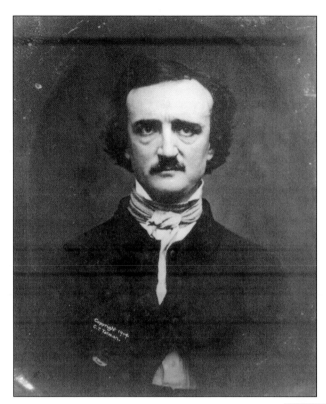

Edgar Allan Poe (1809–1849) was never a resident of Fell's Point. However, his sailor half-brother lived on Caroline Street and was the source of a number of Poe's stories. Poe frequented a bar on Shakespeare that no longer exists. Sheep's Clothing, nearby, was the set for a television program documenting his death. Ghost walk tour guides say his ghost has appeared at the Horse You Came In On saloon on Thames Street.

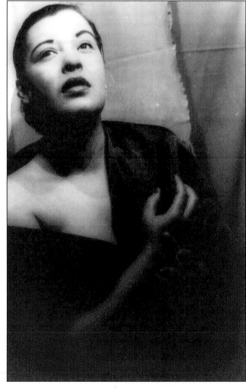

Billie Holiday (born Eleanora Fagan Gough, 1915–1959) moved to 219 South Durham in 1925, and it was there that she was raped by a neighbor. According to local lore, she also played her first public performance in Fell's Point in her Uncle Albert's low house (dive) on Caroline. (Library of Congress, Prints & Photographs Division, Carl Van Vechten Collection, LC-USZ62-89028.)

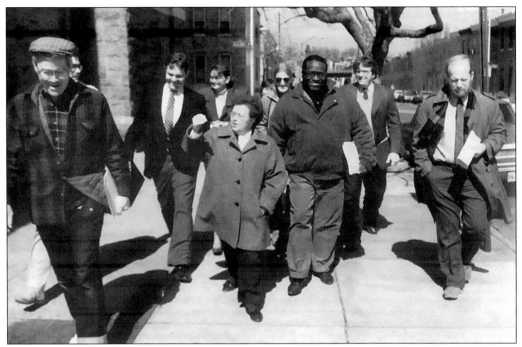

Sen. Barbara Mikulski is another former resident of Fell's Point and longtime benefactor. Her name appears everywhere, from the list of honorary members of the Preservation Society to the side of Living Classrooms' newest building, the Mikulski Workforce Development Center (photo below). Above is an older photo of Senator Mikulski in her Fell's Point district when she was a member of the Baltimore City Council. The sign on Broadway Pier credits her with shouting, during a rally to defeat the expressway, "The British couldn't take Fell's Point, the termites couldn't take Fell's Point, and the State Road Commission can't take Fell's Point."

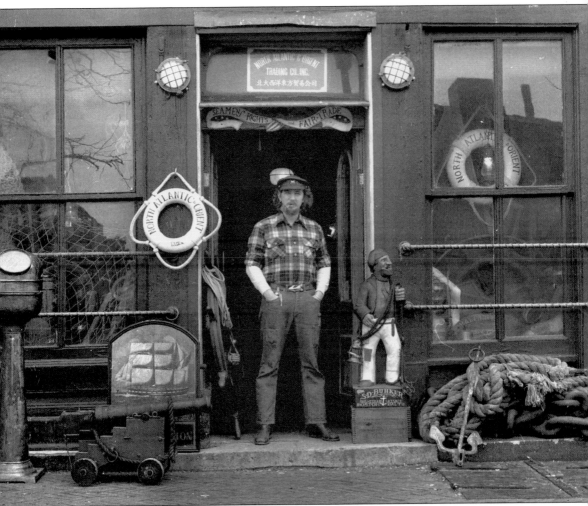

Steve Bunker, who had spent many of his early years on ships, was working as a lobster fisherman in Boston when he was invited to Baltimore to help build a Baltimore Clipper. He spent several years as Baltimore's maritime historian, then opened a shop on Broadway in 1980, pictured above, that eventually grew into the China Sea Marine Trading Co. Bunker, previously a Greenpeace volunteer, got involved in community politics in 1987 when city liquor, health, and housing inspectors began cracking down on local establishments at the request of the Owners, Renters, and Residents Association (ORRA). He and a group of 170 enraged community members stormed the next ORRA meeting and took over the organization. Bunker went on to become a community peacemaker and coalition-builder, helping preserve a number of historic buildings slated for demolition by developers. (Photo by Mark Anthony Kowalski.)

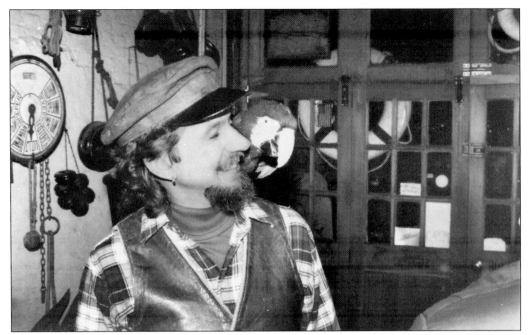

Over the next 20 years, Bunker became, to many, a symbol of Fell's Point. His shop, filled with artifacts, curios, hardware, weapons, mermaids, and even several parrots, reeked of history and became one of Fell's Point's most remembered attractions. (Photo by John Horn, 1988.)

This was Steve's last shop on Ann Street Wharf. Steve Bunker and his partner, writer Sharon Bondroff, left Fell's Point for Portland, Maine, in 1999 after concluding that they could no longer afford to maintain their waterfront business in the face of rising property values. (Photo by Ruth Gaphardt.)

Dantini the Magnificent (Vincent Cierkes, 1906–1979) was born on Thames Street and lived in Fell's Point his entire life. He arrived at his stage moniker by combining the stage names of his two magic idols, Dante and Houdini. During the 1920s, Dantini appeared in several films and met the legendary conjuror Houdini on numerous occasions. In later years, he used this in all his advertisements by proclaiming, "Dantini—he knew Houdini." His most noteworthy achievement was appearing in the original Broadway stage production of *Around The World in 80 Days*, starring Orson Welles.

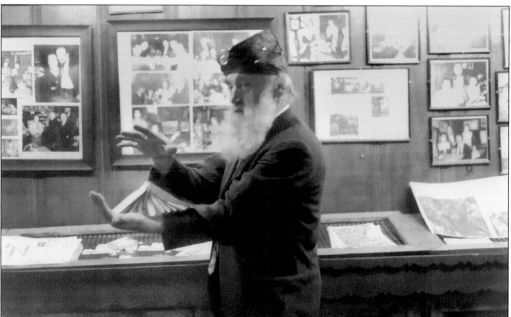

A skillful sleight-of-hand artist, for nearly 20 years Dantini performed at the landmark Peabody Book Shop & Beer Stube, a musty, cluttered, secondhand bookstore on North Charles Street that was a haven for college students, poets, historians, musicians, and traveling celebrities. Here, the gentle-faced magician amused patrons with his famous 15-minute act, featuring card and coin manipulations and closing with the magic linking rings.

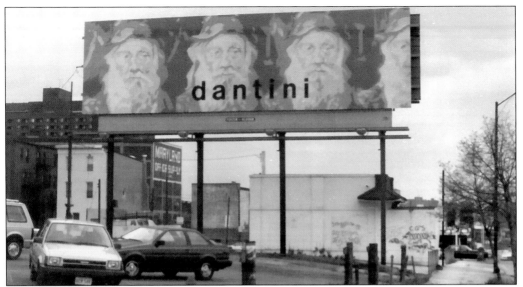

Local artists who frequented the Peabody found Dantini's beard, his unique pawnshop style of dress, and his baleful expression a source of inspiration. He became a regular model for the Maryland Institute College of Art. His portrait by prominent Baltimore artist Joe Sheppard hangs in Los Angeles and Washington, D.C. In 1976, a Fell's Point gallery featured a show of Dantini portraits. In 1986, his friend Paul Moscatt designed the billboard poster above for the Beautiful Billboards for Baltimore competition.

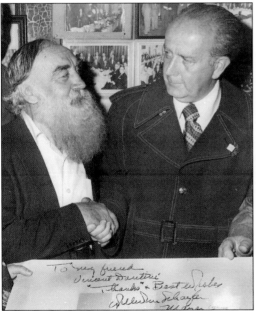
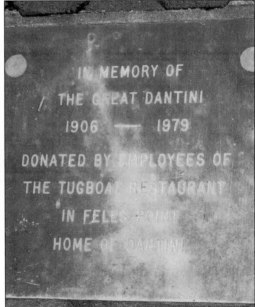

(*Left*) In the 1960s, Dantini also began producing and directing amateur films. His fourth film, a 77-minute documentary titled *Our Baltimore*, premiered at the Civic Center in 1978.

(*Right*) The news of Dantini's death in 1979 received extensive coverage in the local media. His funeral service was attended by the Hon. William Donald Schaefer, then mayor of Baltimore. This memorial plaque, from his friends at Tugboat Annie's (now the Green Turtle), is anchored in the brick sidewalk south of the Market and across the street from Bertha's.

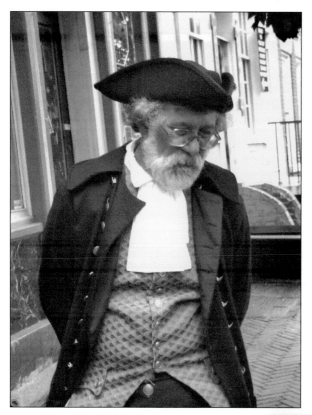

Pastor Jack (P. J.) Trautwein had known about Fell's Point, or the "foot of Broadway," for years but became a regular here after his marriage broke up and he left his West Baltimore church. He purchased a building at 1704 Lancaster Street (below), where he sold crafts. The building caught fire in February 2001 and has only been partially operational since then. P. J. came back into the ministry, initially by performing eulogies for friends he made here. The first was "Ralph Miller" (real name Ed Lawrence but known for drinking Miller beer), followed by Kenny Orye, Harry Reynolds, Jeff Knapp, and, eventually, Ed Kane and Charlie Newton. He married Ed and Cammie Kane and eventually began doing Easter, Thanksgiving, and Christmas services again. These days, P. J. performs as the town crier and also has a "real" church again in Ellicott City. (Photo at left by Ruth Gaphardt.)

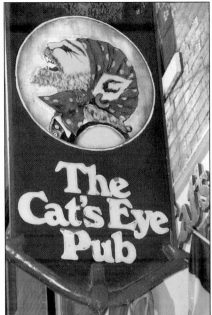

Kenny Orye (1954–1987), founder of the Cat's Eye, hated to have his picture taken but loved to do things people talked about later, including a Fell's Point tea party, a wake at the Cat's Eye for a fictitious IRA leader, a puking contest on the front steps, and a dead doll microwave cremation service. He died at 33 of a drug overdose. (Photo by John Horn.)

Harry Reynolds (1918–1990), a former B&O Railroad employee, owned a bar on Lancaster Street from 1974 to 1983. The bar was publicly identified by a black-and-white sign that, to this day, only says "BAR." "Harry's" was a popular place, despite its off-beat marketing plan. After Harry retired and sold the Bar, he bought *Little Toot*, a 20-foot powerboat custom-designed to resemble a small tug. (Photo by John Horn.)

H. Jefferson Knapp (1929–1992), an Abe Lincoln look-alike, was a bartender at the Cat's Eye Pub and a legendary Fell's Point practical joker. For example, in 1979, Jeff and his buddies convinced the local news that Skylab had crashed in front of the Cat's Eye. Jeff wanted a Viking's funeral with his body on a burning boat pushed out to sea. His friends couldn't do this but instead hired a New Orleans band to march through the streets. (Photo by John Horn.)

Considered the oldest show of its kind in America, Horn's Punch & Judy Show began more than 100 years ago in Baltimore. Professor Horn (Mark Walker) continues this wonderful tradition with his European, hand-carved puppets, Victorian stage, and hurdy-gurdy street organ at the Fell's Point Fun Festival, the Parade of the Lighted Boats, and other events. (Photo by Bryan Burris, reprinted with permission of *Baltimore Magazine*, December 2002.)

Edward M. Kane (1931–2003), a Baltimore native, was the founder of Ed Kane's Water Taxi, the oldest tourism business operating on Baltimore's Inner Harbor and the only private, unsubsidized water transportation system of its kind in the world. He became the voice of Baltimore tourism and was an effective salesman for Fell's Point. Ed lived on Shakespeare Street for many years until his death. (Photo courtesy of Cammie Kane.)

Controversial photographer turned character actor Richard Kirstel got involved with Fell's Point when his brother-in-law, Ed Kane, asked him to do a "Dawn's Early Light" tour. For many years, Richard gave Ghostwalk tours and played living history roles for the Preservation Society. He was so convincing in his performances as a recent immigrant that relatives took up a collection, thinking he was destitute. Richard moved to Spain in 2004. (Photo by Barbara Cromwell.)

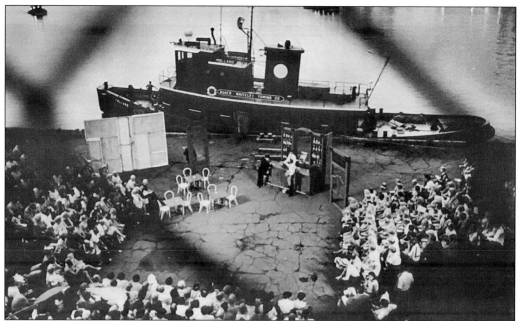

John Bruce Johnson, president emeritus of the Vagabond Players, the oldest continuously operating little theater in America, remembers the performance of *Anna Christie*, shown above on Broadway Pier in 1968, as the players' first experience with Fell's Point. The theater began in 1916 in Mount Vernon. When John got involved in the early 1950s, it was at the Congress Hotel on Franklin Street. In 1968, the theater was again looking for a home, and someone suggested John talk to "Igor at Duda's." In spite of the suspicious-sounding name, Igor turned out to be a businessman in a suit who steered the group to their present location. Below is the 800 block of South Broadway before renovation.

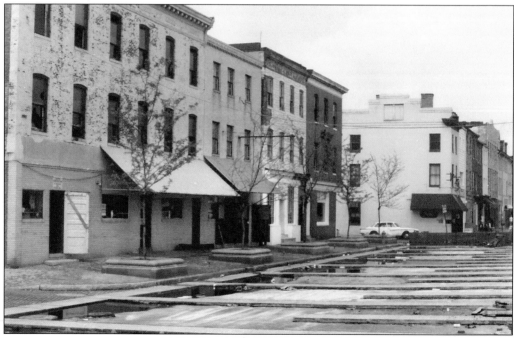

Above are the Vagabond Players during a 1970 performance. (Photos opposite and above courtesy of the Preservation Society.)

Today, thanks to much help from the city and the Fell's Point neighborhood, the Vagabond Theatre is located at 806 South Broadway in a building renovated specifically for the theater. Pictured at right are John Johnson (far left) and a group of longtime theater-goers in 2005.

Vince Peranio, art director and production manager for many of the television shows and movies shot in Fell's Point and elsewhere in Baltimore, has done much to ingrain Fell's Point into the consciousness of America. Vince came here in 1968 after graduating from the Maryland Institute because of the incredibly cheap rents, and he fell in love with the urban, gritty look of the place. (Photo courtesy of the Preservation Society.)

The shots above are from the filming of the 1986 television movie *Liberty*, a drama about how the Statue of Liberty came to be erected in New York Harbor in the early 1880s and the people responsible. One Thames Street resident remembers being kept awake for days with the wagon above being driven down the street all night. (Photo by John Horn.)

During the 1990s, Vince helped steer Barry Levinson to the Recreation Pier (above), which became home to the television series *Homicide: Life on the Street* from 1993 to 1999. The show popularized a number of Fell's Point businesses, including the Waterfront, the Daily Grind, and Jimmy's. Other movies with Fell's Point scenes include *Serial Mom* (1994), *Multiple Maniacs* (1970), *Pink Flamingos* (1972), *Female Trouble* (1975), *Desperate Living* (1977), *Diner* (1982), *Tin Men* (1987), *Avalon* (1990), *He Said, She Said* (1991), *Sleepless in Seattle* (1993), *Washington Square* (1977), *Species II* (1998), *The Replacements* (2000), and *Ladder 49* (2004). (Photo by Anne Gummerson.)

Above, movie trucks line Ann Street working on an episode of *The Wire*.

The Art Gallery of Fell's Point is a non-profit organization that opened in 1980 at 811 South Broadway. Their first building is visible between the dancers at this early Fell's Point Festival. The gallery operates as a collective. Its members volunteer their services in staffing the gallery and in performing administrative duties. Operating expenses are met through membership donations, public donations, visual arts grants, and other fund-raising efforts. (Photo courtesy of the Preservation Society.)

Today, the Art Gallery is a diverse group of 50 artists and operates from a building at 1716 Thames Street.

# *Six*

# ARCHITECTURE
# AND BUILDINGS

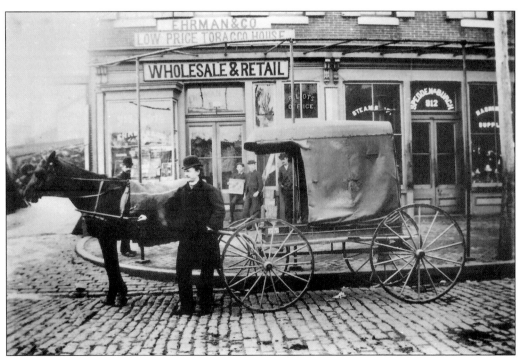

This last chapter explores some of the distinctive features of Fell's Point architecture as well as some of its more interesting buildings. This early photo, of 912 South Broadway, which no longer exists, prominently displays the famous Fell's Point "cobblestones," which are actually Belgian block, granite blocks cut to a regular size and tightly fitted on a base bed of concrete.

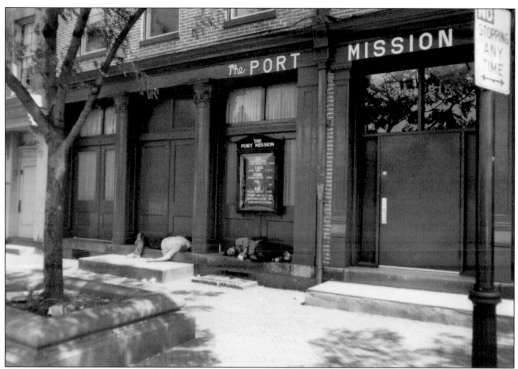

Port Mission was started in 1881 through the preaching of Dwight L. Moody to conduct gospel work among the seamen. It was located at 813–815 Broadway. The building has an 1881 cast-iron decor. (Photo by John Horn.)

Today, the building houses a home furnishings store, Eclectic Elements, which specializes in furniture and decor from around the world.

Jimmy's, the Fell's Point landmark diner and Baltimore's finest "greasy spoon," pictured here in the 1950s, was opened as a candy store in 1946, according to Nick Filipidis, whose father-in-law purchased it from his father in 1980. It became a diner in 1987 and, in the 1990s, was featured in a number of shows in the television series *Homicide: Life on the Street*. The building was built in the mid-1800s and was originally a clock shop. (Photo courtesy of Billy Colucci.)

Today, Jimmy's still serves Fell's Point customers. The building next door on the right is a seasonal H&R Block. In recent history, it has also housed a plant shop, a saddle shop, a food shop, a florist, and a T-shirt shop. Two doors down is the Whistling Oyster, home of the Fell's Point Yacht Club and a haunted stairway.

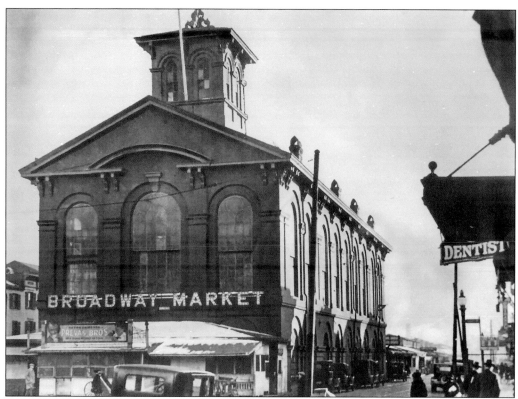

The Broadway Markets date back to 1784. Originally, the northernmost market had an upper floor that served as a dance hall and meeting room. The second story was expensive to maintain and was removed in the 1950s or 1960s after a fire. (Photo by the *Baltimore News American*, courtesy of the Hearst Corp.)

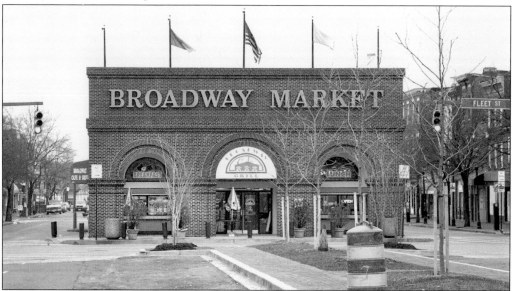

Today, the rebuilt Broadway Market is a much shorter, less elegant place, without any community space.

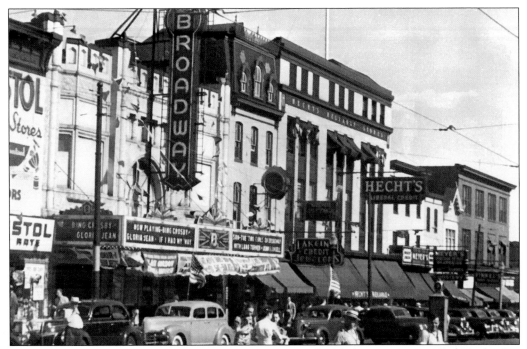

In the 1950s, Broadway above Fleet Street was a wonderful shopping area. The Hecht Co. was founded in Fell's Point in 1857 by a German-Jewish couple. Their first building, pictured above, was in the 500 block of South Broadway, next to the Broadway Theater. (Photo courtesy of Billy Colucci.)

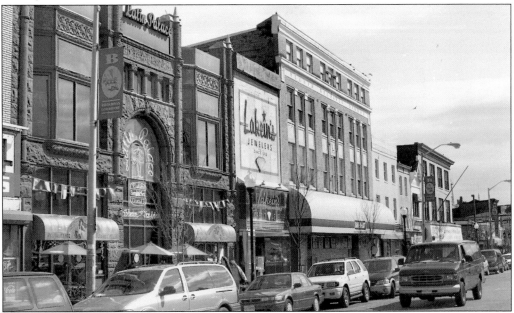

Today, Broadway below Fleet Street is the fashionable area and "Upper Fell's Point," also known as Spanish Town, is being revitalized by the Latino community. The building above still has "Hechts Department Store" inscribed in the facade, but it is now home to a discount grocery. The Latin Palace occupies the Broadway Theater building.

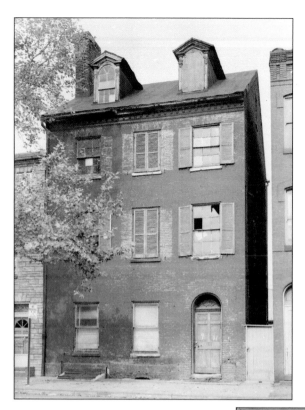

The most famous Fell's Point homes were "sea captains' houses," owned by prosperous merchants and shipyard owners. (The title "captain" was often awarded to shipbuilders, even if the person did not command a ship.) One of the best-known examples of these spacious, well-constructed buildings is the Captain Steele House at 935 Fell Street, photographed in 1960. (Library of Congress, Prints & Photographs Division, HABS, MD-189.)

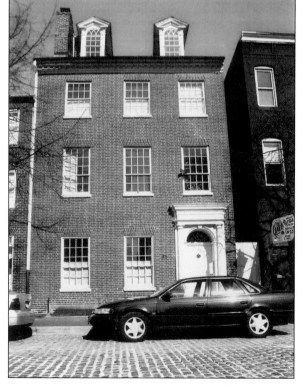

The house was built in 1786 by Jesse Hollingsworth, a prominent merchant and major purveyor for Washington's armies. Wealthy shipbuilder Capt. John Steele purchased it in 1796. It was remodeled by Jean Hepner, one of the founders of the Preservation Society, and her husband. The home is noted for its beautiful interior woodwork and exemplifies the type of home built by prosperous merchants and shipyard owners. (Photo by Ruth Gaphardt.)

A beautiful example of the inside of a captain's house is the home of Tony and Laura Norris, owners of Bertha's. (Photos by Anne Gummerson.)

Many Fell's Point homes have a built-in alleyway between the buildings, locally known as a "sallyport." The term is of military origin and is defined as an "opening in fortifications from which defenders may make a sally." The sallyport connected the backyard with the street so people could take their livestock to graze in the common fields on the outskirts of the village. (Photo courtesy of the Preservation Society.)

Working-class homes were typically very narrow, built on lots 12 feet wide or less. In this 1940s photo of a row house kitchen at 2203 East Lombard, the furniture on both sides of the room is visible—a shelf on the left and a washer and cabinet on the right. (Photo courtesy of Robert Betlejewski.)

In an effort to fit more people into Fell's Point's tiny row houses, immigrants often converted attics to third floors. This house at 1611 Lancaster Street is an example. The first two floors are obviously a different style of architecture than the third.

When the home was remodeled, the inside bricks in the third floor were left exposed, and the original brick sidewalls and roofline are visible (below). According to Robert Eney, the main body of this house is built out of ballast or "bastard brick" that was dumped by the shippers on the dock. The builders of this house actually built the main body of the house out of these little skinny bricks.

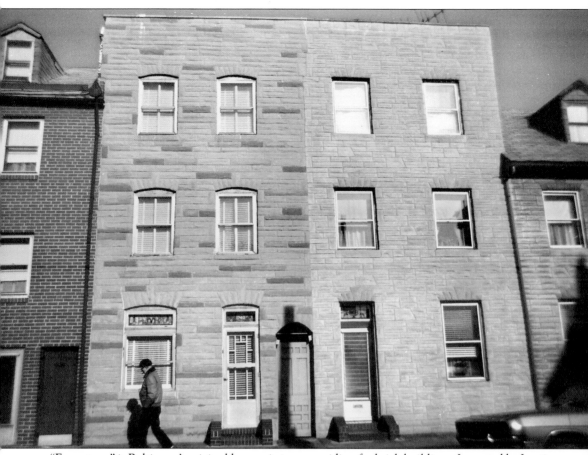

"Formstone" is Baltimore's original low-maintenance siding for brick buildings. Invented by Lasting Products, it consists of a molded mixture of cement, pigment, and stone applied directly to the outside of the building. According to Lillian Bowers in a 1940s Preservation Society newsletter article, other companies entered the market with imitations, such as Permastone, Fieldstone, Stone of Ages, and Crystalstone, some of which were of lower quality. Formstone and its imitations were sold by salesmen on commission; these salesmen inspired the Barry Levinson movie *Tin Men*, about aluminum siding salesmen in Baltimore. Properly applied, formstone reduced maintenance and heating costs and provided an opportunity for customization with its different patterns and colors. Poorer quality imitations, however, often developed cracks that allowed water to seep inside, causing extensive damage to the bricks. When older row houses are restored or modernized, any formstone exterior is almost always removed. Shown here is 1740 and 1742 Lancaster Street in 1983. (Photo courtesy of the Preservation Society.)

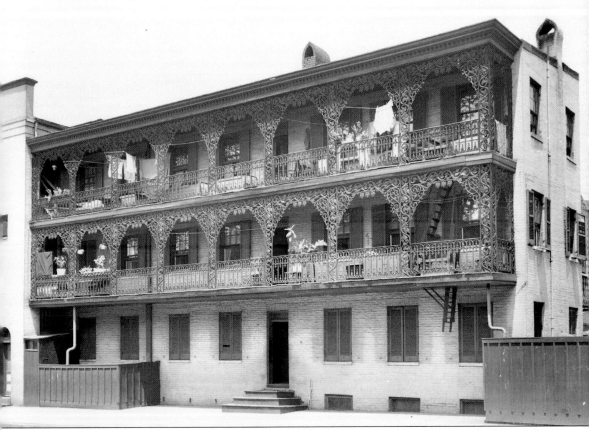

Cast decorative iron railing was a <u>Baltimore manufacturing</u> specialty a century ago, and substantial quantities were <u>exported to New Orleans and San Francisco.</u> Although less and less of it survives in Baltimore as time goes on, a number of older buildings in the Fell's Point area still have beautiful examples, like this home at Broadway and Lombard. Some of the commercial buildings, such as the Port Mission, also had cast-iron fronts. (Library of Congress, Prints & Photographs Division, HABS, MD-374.)

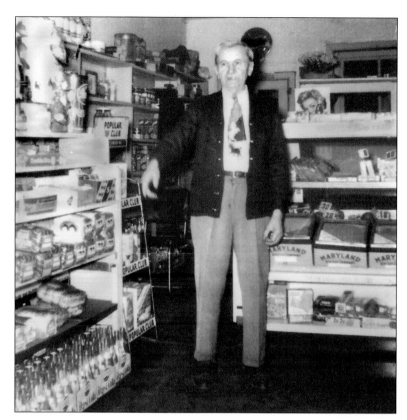

The Black Olive, at 814 South Bond Street, was created by Stelios and Pauline Spiliadis and their son Demitris. Stelios is the grandson of a Greek couple who built a hotel and restaurant on the shores of the Black Sea. When the Greeks were forced out of Turkey in the 1920s, the family opened up a tavern in the city of Patras. The original restaurant had been a Polish grocery. The pre-1950s photo at left shows Vincent Kozierachi inside his grocery store.

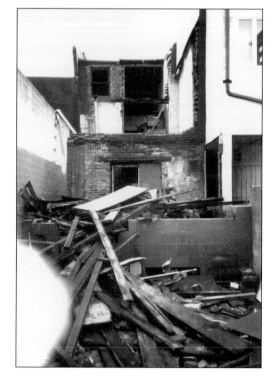

On the right is the back of the building during renovation. There had been a number of cinderstone additions over time that were not even attached to each other. The carriage house in back was so structurally unsound that there was no way to save it.

During the renovation of a typical row house, the building is often gutted and the walls and floor joists exposed. Above is the Black Olive at this stage. The renovation was complete, and the Black Olive opened in 1994.

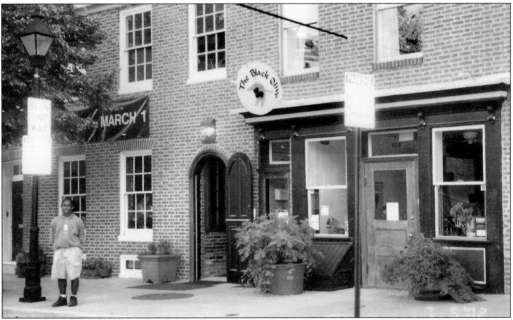

In 2002, the family expanded the restaurant into a larger building next door (left side of the photograph) at 816 South Bond. That building had been the home of Baltimore's first newspaper, the *Maryland Journal and Baltimore Advertiser*, opened in 1773 by the brother-and-sister team of William and Mary Katherine Goddard. (Photos courtesy of Pauline Spiliadis.)

Less than a block away, at 1609 Shakespeare Street, Pauline and Stelios Spiliadis have helped preserve another piece of Fell's Point's history. The building, believed by Robert Eney and other historians to be William Fell's first house, was in sad shape in 1997 when they purchased it. It had been one of the buildings condemned by the city for the freeway and had fallen into extreme disrepair.

When the formstone front (page 18) was removed, the building started to collapse. It was photographed and meticulously rebuilt to the original design. The house had undergone three major renovations that expanded it, raised the roof, and changed the front windows and sallyport. Also, the property line curves toward the back of the building. (Photos courtesy of Pauline Spiliadis and the Preservation Society.)

The fully restored front of the building is patterned after a similar Quaker house in Philadelphia. Like the Robert Long House (pages 62–63), it has had the added third floor removed and the pent roof restored. The sallyport at the front was also removed, along with the added front window on the first floor. The empty lot barely visible on the right houses the Fell family tomb (page 12).

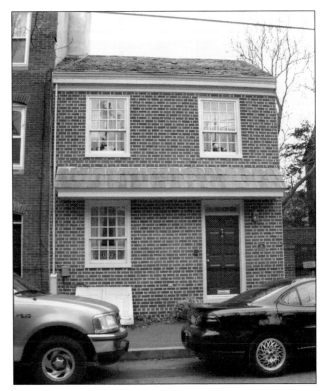

The house on the other side of the Fell graveyard at 1605 Shakespeare is an example of a "half house." According to Robert Eney, the light-colored stuccoed front half was built in 1792, but the owners didn't have enough money to build a two-room-deep house. In about 1818, the darker brick back of the house was added.

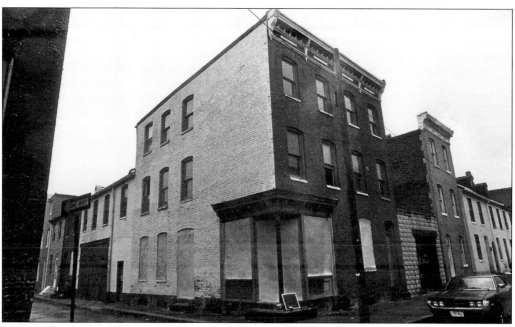

This building at 1620 Shakespeare dates back to the early 1800s. In the early 1900s, it was a bakery owned by the Obrycki family. During the 1950s and 1960s, it was a boardinghouse. At the time of this photograph, the City had purchased the building in anticipation of building the expressway through it. Charles and Darcy rehabilitated the building and opened Sheep's Clothing there in 1981. The photo on the lower left, taken in 1993 by Anne Gummerson, shows the couple in front of their shop. On the lower right is Sheep's Clothing today.

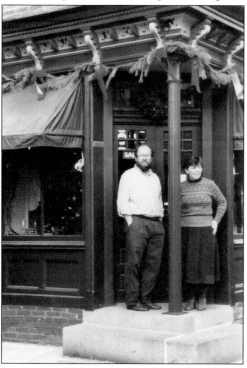

This building at 1708 Fleet Street (once known as Canton Avenue) began as Harry Sander and Sons' funeral home and furniture manufacturing business in 1853. From 1941 through the mid-1950s, the building was the home of the Polish National Alliance. Joseph Frank purchased it in 1991, spent six months remodeling it, and opened the doors to his antique shop, Another Period in Time, on November 9.

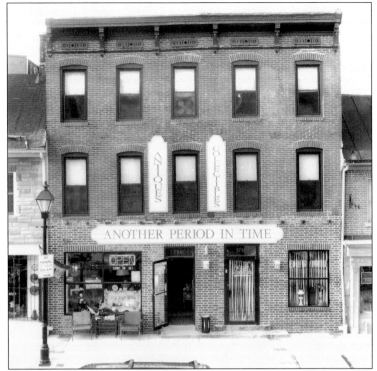

The celebration at the end of the remodeling was unfortunately short-lived. The city spent the next year repaving the street in front of the building, almost putting Frank out of business. (Photos courtesy of Joseph Frank.)

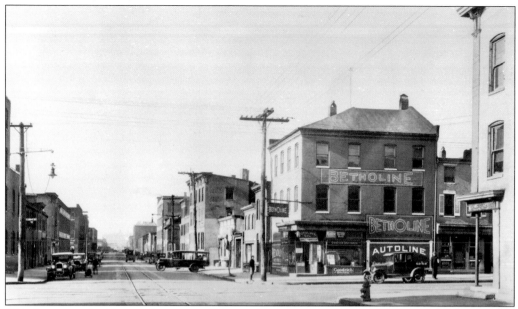

This three-story building at the corner of Fleet and Bond is the site of one of the richest archeological excavations in Baltimore and has appeared on Maryland Public Television. In 1830, a handful of Jews worshiped for two years on the second floor above a grocery, the first public synagogue in Maryland. The 1910 photo above was featured in *The First Rabbi*, by I. Harold Sharfman, D.H.L. (Photo courtesy of the Baltimore Hebrew Congregation.)

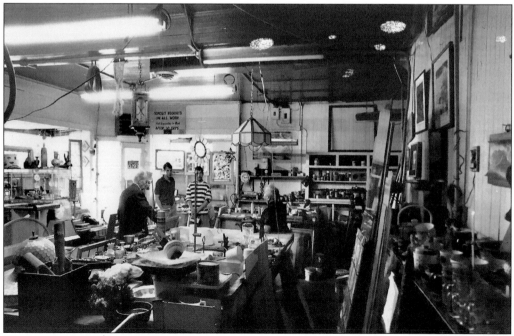

The structure was built in 1797 and has served as a private home, a saloon, a market, a synagogue, a boardinghouse, an auto parts store, and, as recently as the early 1990s, a stained-glass shop. The youngest son of one of the signers of the Declaration of Independence, Francis Hopkinson, lived here for 15 years. This photo by Jesse Schwartz shows the inside before renovation began.

Above is the fireplace excavated from the basement of the house that would have supported the fireplaces above. On this site and the one next door, a total of 14 privies were excavated. Enough pottery was found to indicate that this was a major 18th-century site and that a diverse flow of ethnic groups came through the building's doors. Below is how the building looks today. (Photo above by owner Brian Schwartz.)

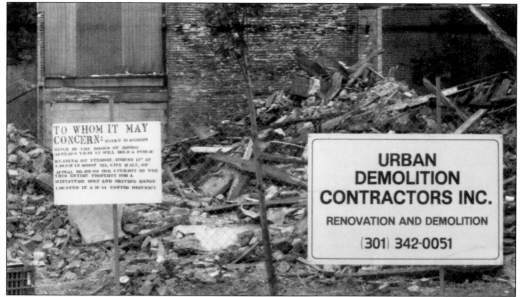

The buildings above in the 1700 block of Lancaster were torn down in 1986. Memories disagree on the process. "They demolished them on a weekend without a permit and the police did nothing." "The buildings were already falling down. One even collapsed on a parked car." "Developers knew how to help old buildings fall down." "The buildings were owned by the Dashiells and were going to be a major museum." Jeff Knapp posted a bogus zoning notice for a miniature golf and driving range. A neighbor told a newspaper reporter that he knew the sign was suspect because there was no mention of a liquor license transfer. (Photo by John Horn, 1986.)

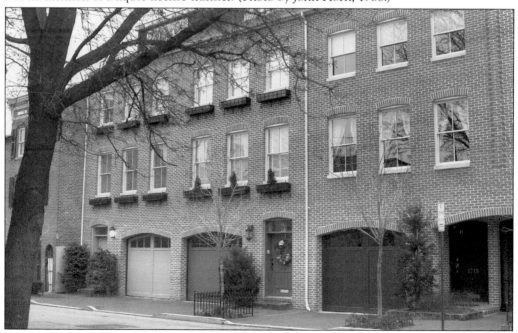

The site sat empty for over 10 years. The series of high-end town homes pictured above was eventually built there. Their selling prices in 2001 were unimaginable to longtime Pointers—from $400,000 to $600,000!